Published in 2022 by Search Press Ltd.
Wellwood, North Farm Road
Tunbridge Wells
Kent TN2 3DR

Reprinted 2023, 2024, 2025

This book is produced by
The Bright Press, an imprint of the Quarto Group,
1 Triptych Place, London
SE1 9SH, United Kingdom
www.quarto.com

ISBN: 978-1-80092-033-0
ebook ISBN: 978-1-80093-026-1

Conceived, designed and produced by The Bright Press,
an imprint of Quarto Publishing plc

Publisher: James Evans
Editorial Director: Isheeta Mustafi
Art Director: James Lawrence
Managing Editor: Jacqui Sayers
Development Editor: Abbie Sharman
Project Editor: Polly Goodman
Design: JC Lanaway

Printed and bound in China

10 STEP DRAWING

Cats

DRAW OVER (50) FABULOUS FELINES
IN 10 EASY STEPS

JUSTINE LECOUFFE

Search Press

Contents

⫸ Faces & features

⫸ Cats at rest

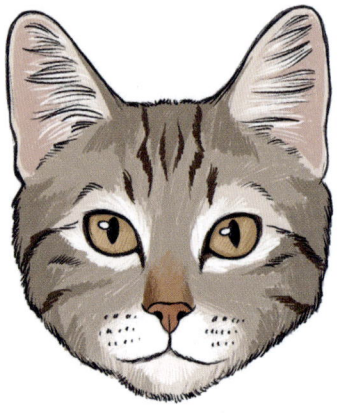

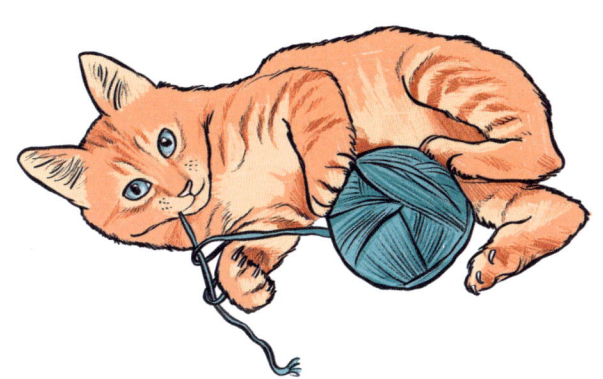

>>> Cats in motion

>>> Cats & kittens

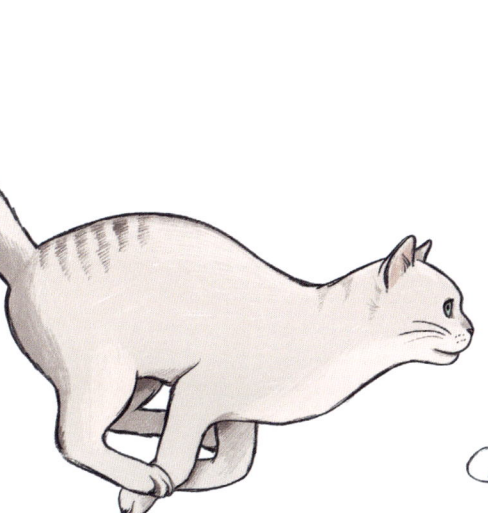

Introduction

In this book, you will find more than 50 illustrations of clever cats and cute kittens that have been created in just 10 simple steps. So, whether it's a fluffy RagaMuffin, a spotty Bengal or a sleepy tabby curled up on her favourite rug, it's time to choose your favourite feline friend and get drawing!

TACKLING DIFFERENT SHAPES

Cats and kittens come in all different shapes and sizes. The step-by-step instructions show you how to use simple shapes or outlines as guides for placing heads, limbs and tails. This will enable you to get the proportions right.

At the beginning of each chapter, you will find a guide for drawing basic head profiles, facial features and poses. Once you've mastered the basics, you can move on to applying these techniques to 34 different breeds.

Follow the instructions and guides for the shapes of the heads, bodies, legs and tails to help you achieve a realistic appearance for different breeds, as well as a variety of natural poses, from grooming and stretching to balancing, running and jumping.

I have also provided a colour palette at the end of each finished drawing. Use this as a guide, but feel free to experiment and use your favourite shades for the cats' fur.

I hope you will enjoy creating the images in this book as much as I did. Drawing cats has never been easier!

6

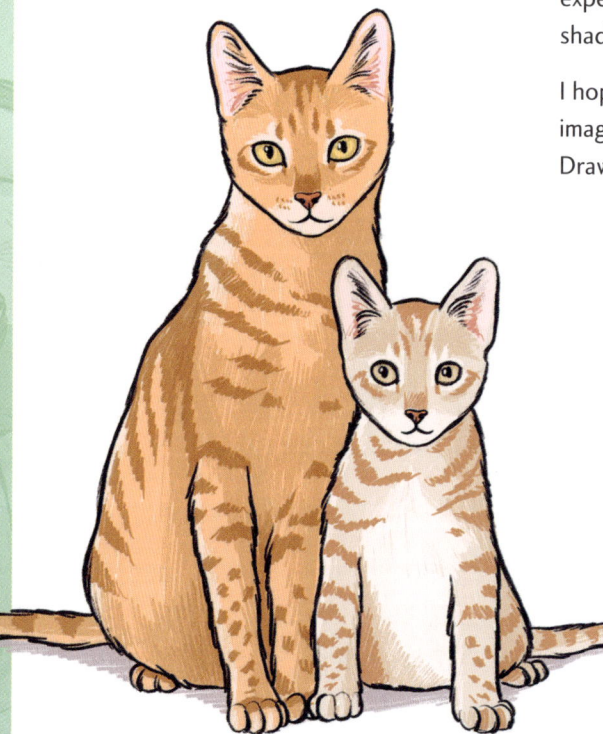

How to use this book

BASIC EQUIPMENT

Paper: Any paper will do, but sketch paper will give you the best results.

Pencil, eraser and pencil sharpener: Try different pencil grades and invest in a good-quality eraser and sharpener.

Coloured pencils: A good set of coloured pencils, with about twenty-four shades, is really all you need.

Small ruler: This is optional, but you may find it useful for drawing guidelines.

FOLLOWING THE STEPS

Use pencil to trace the shape guidelines in each step. Use a dark-coloured pencil to add the outlines and details. Then erase the underlying pencil. Finally, apply colour as you like.

COLOURING

You have several options when it comes to colouring your drawings – why not explore them all?

Pencils: This is the simplest option, and the one I have chosen for finishing the pictures in this book.

Stay inside the lines and keep your pencils sharp so you have control in the smaller areas.

To achieve a lighter or darker shade, try layering the colour or pressing harder with your pencil.

Cat fur comes in different colours and has different patterns and textures, so once you're confident with where the shading should be on each one, try varying the tones you use.

Paint and brush: Watercolour is probably easiest to work with for beginners, although using acrylic or oil means that you can paint over any mistakes. You'll need two or three brushes of different sizes, with at least one very fine brush.

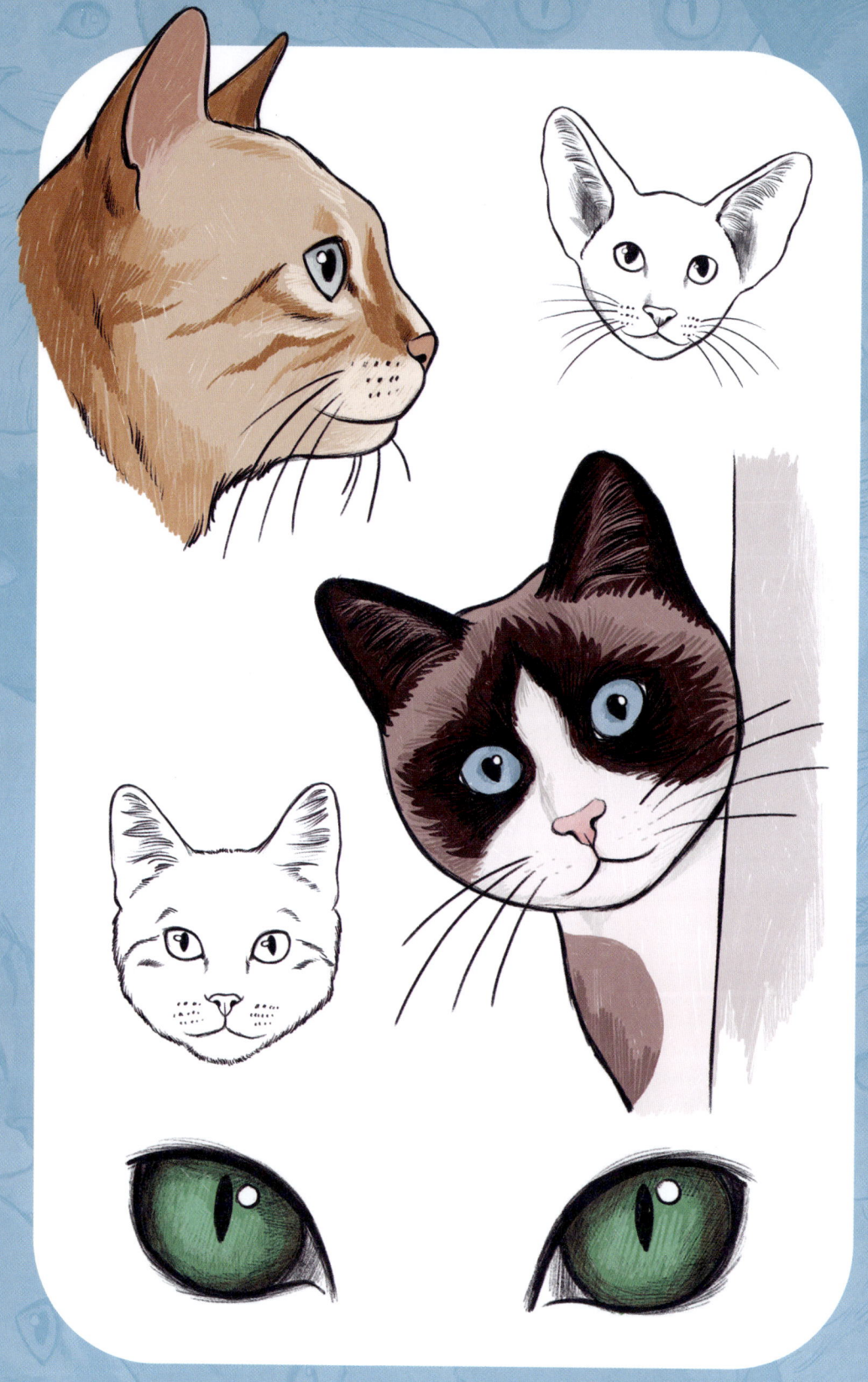

Faces & features

Front view:
Face

For a classic feline face, start with a horizontal oval, or draw the sides
closer to the initial circle guidelines for a narrower structure.

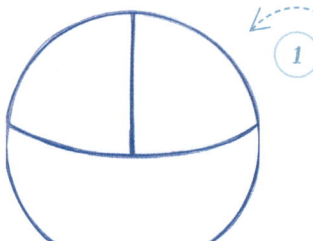

1 Draw a circular guide. Add a
curved, horizontal line crossing
the head and a vertical line
through the top half.

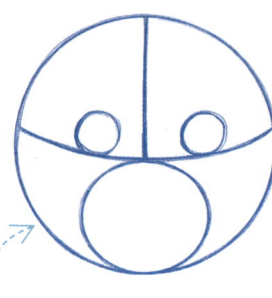

2 Draw small circles for the
eyes. They should be the
same size, at a roughly
equal distance from the
vertical line. Draw a larger
circle for the muzzle.

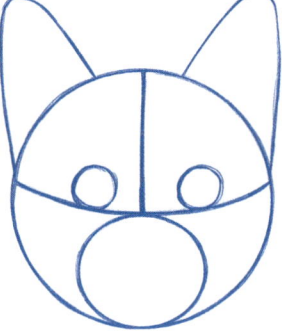

3 Add two tall arcs
for the ears.

10

4 Draw the eyes, making them
pointier at the inside corners. Add a
sharp, oval shape for the pupil, with
a tiny highlight circle beside it.

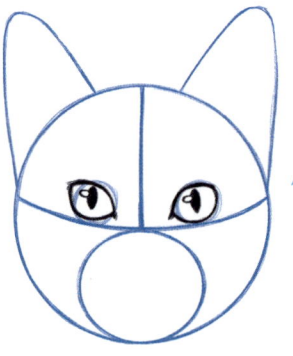

5 Draw the nose, using a wavy line for the top
edge. Make the top corners longer so they point
towards the eyes. Make the sides curve inwards
as you draw the nostrils. Make the bottom tip
pointed and add a short, vertical line.

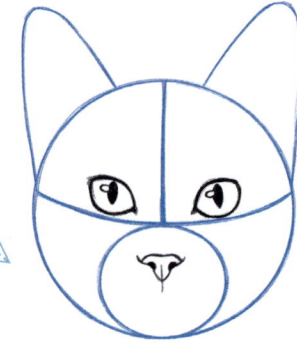

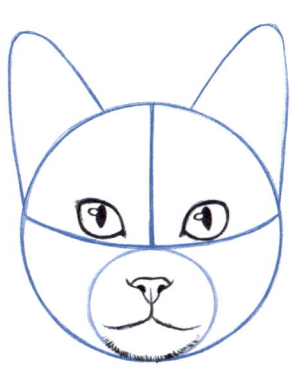

6 Add the mouth by first drawing a short, vertical line under the nose. Sketch two lines that split and curve towards each edge of the initial circle, using short strokes to represent fur. Draw the chin using short strokes.

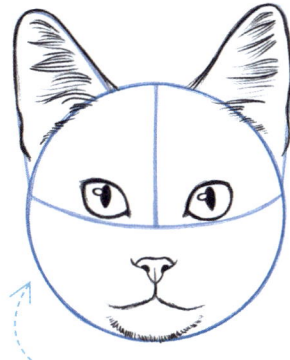

7 Darken the ears, using short, curved lines. Add further strokes across the middle for the fur inside the ear.

8 Draw the rest of the head, making the sides a little wider.

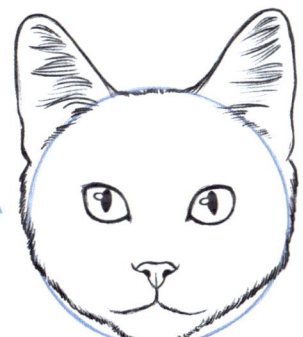

9 Erase your guidelines. Add some strokes inside the face for extra detail.

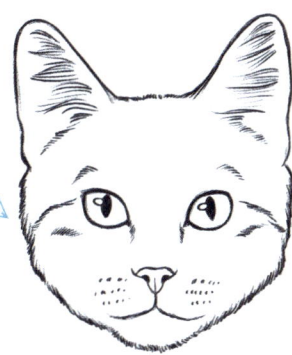

10 Add a light brown base colour, pink for the ears and nose and light brown for the eyes. Finish with darker tones towards the nose, cheeks and forehead.

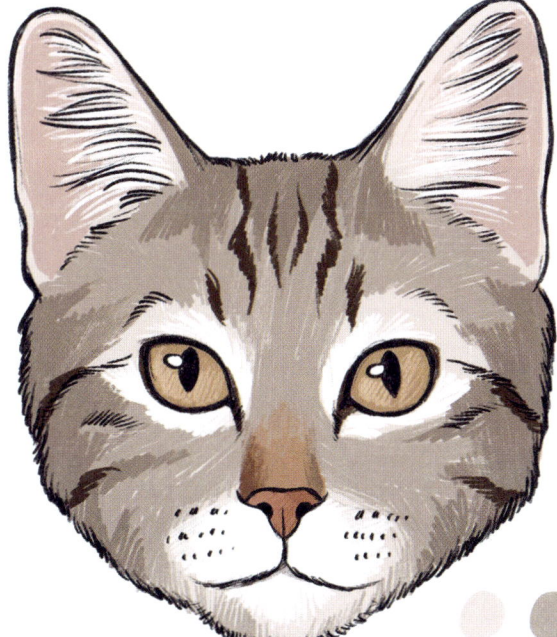

Side view:
Face

This side profile really captures the character of the cat, with its pointy ears and long whiskers. Adapt these simple instructions for any breed.

1 Draw a circle guide. Add a squarish muzzle shape.

2 Trace a horizontal line crossing the head, touching the top of the muzzle.

3 Add two triangular shapes for the ears.

4 Trace the eye in the shape of a triangle with a curved edge. Add a sharp, oval pupil, with a tiny highlight circle beside it.

5 Sketch a triangle for the nose at the tip of the muzzle. Add a small nostril shape.

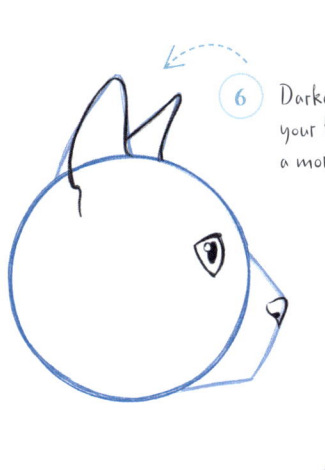

(6) Darken the ears, making your lines more curved for a more natural look.

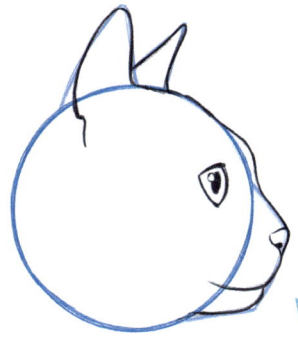

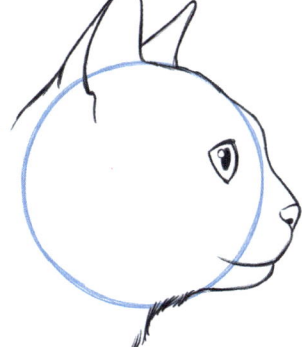

(7) Under the nose, draw a line that curves back towards the circle for the upper lip. Draw a parallel line under it for the chin. Link the tip of the nose to the ears.

(8) Draw the neck and back of the head. Erase your guidelines.

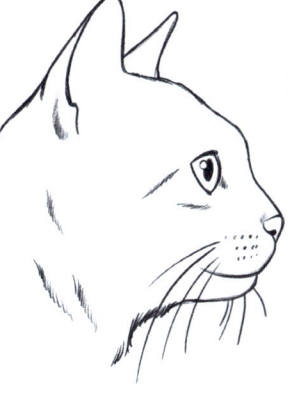

(9) Add some strokes for extra detail around the face. Add some long whiskers at each side.

(10) Add a light beige base colour, pink for the ears and nose and light blue for the eyes. Finish with darker tones towards the nose, cheeks and back of the head.

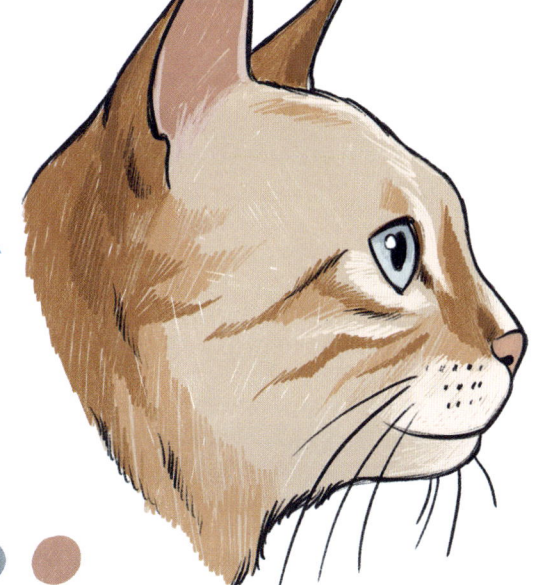

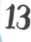

Eyes

Cats' eyes slant diagonally – the outside corners are positioned higher than the inside corners. The fur around the eyes is usually lighter in colour, too.

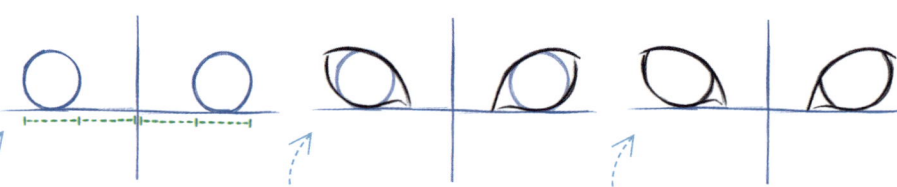

1 Trace two crossing guidelines. Draw two circles on the horizontal line. The dotted green line helps with symmetry – there should be the equivalent of one circle between each circle and the vertical line.

2 Trace the outlines of the eyes. The lower eyelid is more circular and the top is much flatter.

3 Trace the eyeball within the eyelids with a few curved lines.

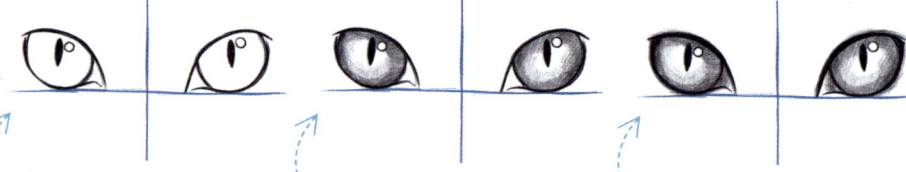

4 Add two small lines for the pupils, with a tiny reflection circle to one side of each.

5 Shade the details, using darker shading towards the reflection side of the eyes for a realistic effect.

6 Refine the outlines, adding thicker, darker lines to the eyelids.

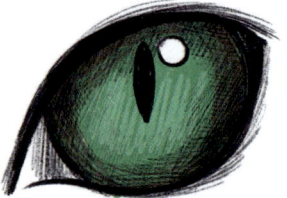

7 Erase your guidelines. When adding colour, keep the darker tones for the edges and the lighter tones towards the centre.

14

Features
Nose

The nose is the cat's most important sensory organ. Cats have over 200 million odour sensors in their noses; humans have just five million.

1 Trace a circle guide for the muzzle. The dotted green line should help you place the starting point of the nose.

2 Start tracing the nose with a Y-shape.

3 Trace a little hook on each side to create the nostrils.

4 Add an additional line, and then darken the curved shapes to finalize the nostrils.

5 Darken the top edge using a wavy line.

6 From the vertical line at the bottom, trace two small curves on each side to create the mouth.

7 Add shading to the top of the nose, little dots to create the whiskers, and a series of strokes along the lower edge of the circle to create the chin.

8 Erase your guidelines. Colour the nose in warm pink, with lighter tones at the top and darker tones at the bottom.

Ears

Ear shape varies according to breed. The Maine Coon's ears have a specific style with hair at the tips, whereas the Scottish Fold's ears live up to their name.

Generic

(1) Draw an arced, triangular guideline for the ear.

(2) Start tracing the outlines. Don't make the ear too pointy – avoid straight lines and add some curve to the shape.

(3) Trace the ridge around the ear as a line parallel to the outer edge.

(4) Add inner fur. It grows from the inside of the ear towards the external side.

(5) Erase your guidelines. Use light pink for the skin inside the ear, and a lighter tone than the outside of the ear for the inner fur.

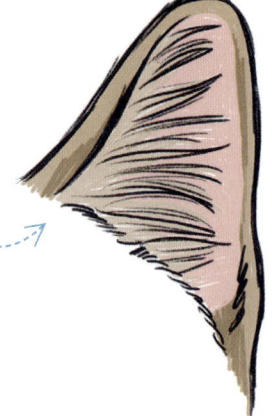

16

Maine Coon

1. Trace a pointed, triangular guide.

2. Draw the first side of the ear outline. Add a few long strokes at the tip.

3. Add the inner fur with very long strokes that pop out of the side.

4. Finish tracing the outline of the ear, making sure you do not overlap the inner fur.

5. Erase your guidelines. When adding colour, make sure that the inner fur is lighter.

Scottish Fold

1. Trace a wider triangular guide, making it less pointy than usual.

2. Start tracing the ear fold at the top.

3. Add some shading under the fold. Keep tracing the ear outline on the other side.

4. Draw the base of the ear.

5. Erase your guidelines. When adding colour, make the inner ear darker.

Birman

Now you have mastered feline faces, try this beautiful Birman. This cat has a colourpoint pattern, which means its coat is darker on the face, ears, paws and tail.

1 Draw an oval guide.

2 Add two triangular ears.

3 Draw a large, triangular guide for the furry neck.

4 Draw two straight, intersecting guidelines across the head to help you place the features later. Add a tiny, horizontal line in the centre of the bottom half.

5 Trace the pointy, almond-shaped eyes. In the middle of each eye, draw a sharp, oval shape for the pupil, with a tiny highlight circle beside it. Sketch a small triangle for the nose, curving each side inwards to create the nostrils.

18

6 Darken the ears, using short strokes for a furry effect. Continue drawing short strokes along the head and neck outline.

7 Under the nose, draw a line that splits in two and curves to the left and right for the mouth. Draw a curved line using short strokes for the chin. Add shading to the eyes, along the nose and on the muzzle.

8 Erase your guidelines. Add some strokes for extra fur detail around the face and inside the ears, and add some long whiskers.

9 Use a light beige as a base colour, and light blue for the eyes.

10 Finish the colouring with dark grey for the mask and ears.

Chartreux

This rare French breed has a plush blue coat and gorgeous golden eyes.
Highly affectionate, they love to climb, but also adore a warm lap.

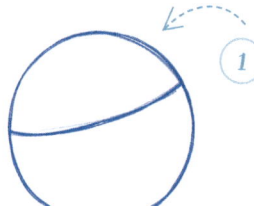

1 Draw a circle guide, with a curved line across the centre.

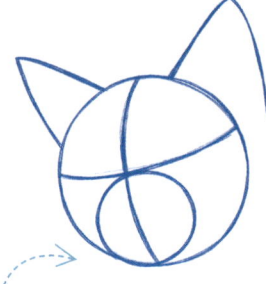

2 Add a curved, vertical line, and place a circle on the lower part as a muzzle guide. Draw two triangular shapes for the ear guidelines, making sure that the end doesn't meet the head circle for the ear on the right side.

20

3 Trace a few more lines for the neck.

4 Start tracing the round, pointy eyes. In the middle of each eye, draw a sharp oval for the pupil with a tiny highlight circle to the side of each.

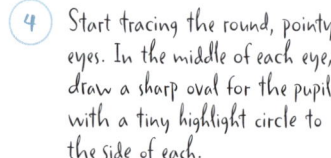

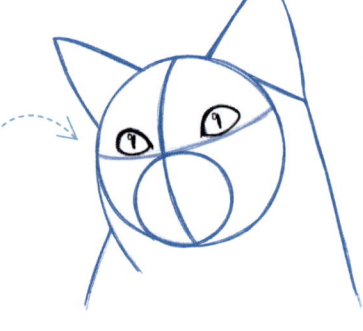

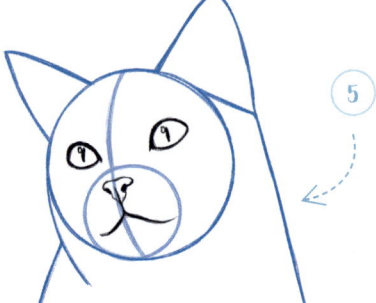

5 Along the vertical guideline, sketch the nose. Curve each side inwards to create the nostrils. Under the nose, draw a line that splits into two and curves to the left and right for the mouth.

6 Darken the ears. Draw a curved line for the chin and add whiskers on each side of the nose.

7 Continue making short strokes along the outline of the head.

8 Erase your guidelines. Add some strokes for extra detail around the eyes and below the ears.

9 Add light grey to the head and pink to the ears.

10 Add darker grey shading to finalize your drawing, and colour the eyes in a warm yellow.

Faces
Oriental Shorthair

These intelligent, vocal and athletic cats are known for their angular faces, wide-set ears and silky smooth coats in various colours.

1 Draw a circular guide.

2 Draw two intersecting lines across the head, angled towards the right.

3 Add a circular muzzle guide.

4 Add two large, triangular ears to the length of the head's diameter.

5 Draw two round eyes, with almond-shaped pupils and tiny highlights inside. Sketch the nose, curving each side inwards to create the nostrils. Draw a line that splits into two and curves to the left and right for the mouth.

22

6 Darken the ear shapes, using short strokes inside for a furry effect.

7 Continue drawing short strokes along the outline of the head, making it more triangular than round.

8 Erase your guidelines. Add some strokes for extra detail around the eyes and inside the ears. Draw some long whiskers.

9 Use light brown as a base colour, bringing in some warm pink tones for the inside of the ears.

10 Add light green to the eyes. Colour some darker stripes on the forehead and around the eyes. Colour the nose using the same pink tones as the inner ears.

Maine Coon

The Maine Coon's head is taller than it is wide and is recognizable by its long, pointed ears, large, muscular stature and glorious, semi-long coat.

① Draw a circle guide. Add a curved, horizontal line across the centre and a vertical line through the top half.

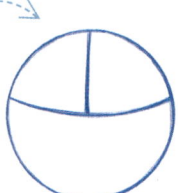

② Draw two circles for the eyes, sitting on the horizontal line, and a larger circle for the muzzle.

③ Add two tall, triangular ears and a large, V-shaped guide for the furry neck.

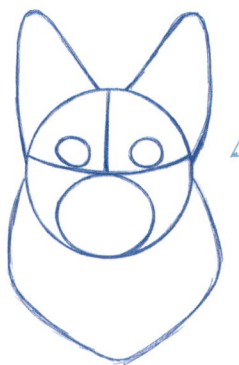

④ Trace the large, round eyes. Draw a sharp, oval shape in the centre of each eye for the pupil, with a tiny highlight circle to the side.

24

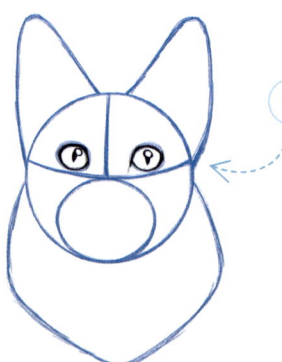

⑤ Within the muzzle circle, sketch the nose. Curve each side inwards to create the nostrils. Continue with two curved lines for the mouth.

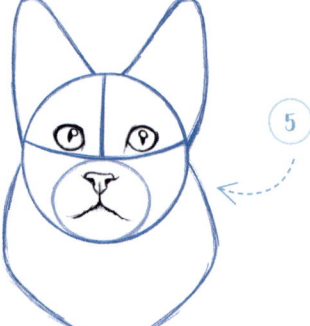

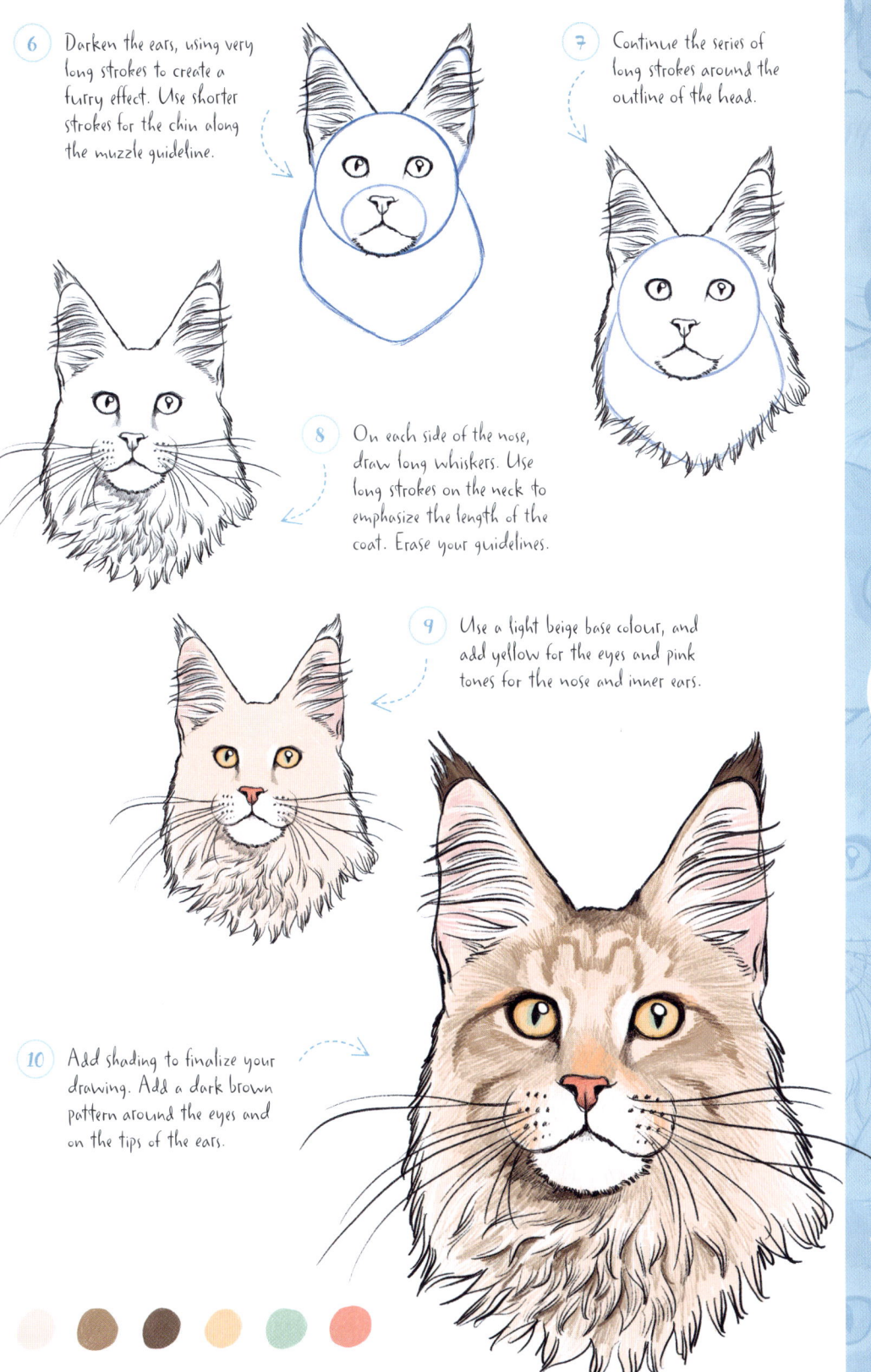

6 Darken the ears, using very long strokes to create a furry effect. Use shorter strokes for the chin along the muzzle guideline.

7 Continue the series of long strokes around the outline of the head.

8 On each side of the nose, draw long whiskers. Use long strokes on the neck to emphasize the length of the coat. Erase your guidelines.

9 Use a light beige base colour, and add yellow for the eyes and pink tones for the nose and inner ears.

10 Add shading to finalize your drawing. Add a dark brown pattern around the eyes and on the tips of the ears.

Singapura

The Singapura is the smallest domestic cat breed, but it has a big personality.
It is known for its saucer-shaped eyes, oversized ears and unique colouring.

1 Draw a circle guide.

2 Add a curved, horizontal line crossing the centre and a vertical line through the top half.

26

3 Draw a circular muzzle guide.

4 Add two large, oval eyes along the horizontal line.

5 Add two tall, triangular ears.

6 Sketch the eyes as two large ovals, making the insides pointier.

7 Inside the muzzle, sketch the nose. Finish with two curved lines for the mouth.

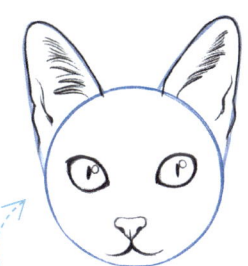

8 Draw the ears, adding strokes for the fur inside.

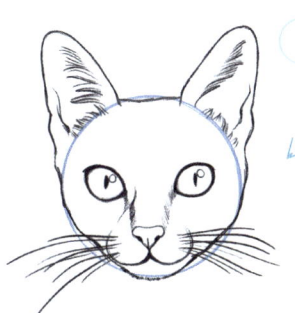

9 Complete the head outline with short strokes, making it a little more triangular by drawing the cheeks on the inside of the circle guide. Add whiskers. Erase your guidelines.

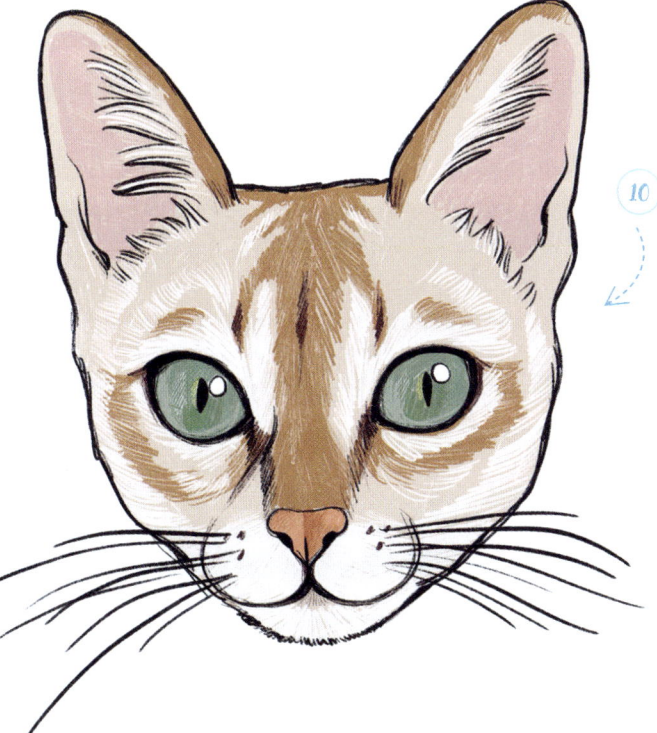

10 Colour the head in light beige and add darker brown tones towards the middle of the forehead, down to the tip of the nose. Colour the nose in light brown, the inner ears in light pink and the eyes in green. Leave a tiny highlight circle uncoloured in each eye.

RagaMuffin

The RagaMuffin's head is medium-sized, but its semi-long, furry coat makes it appear larger. This cat's walnut-shaped blue eyes and docile nature will melt your heart.

1 Draw a circle guide.

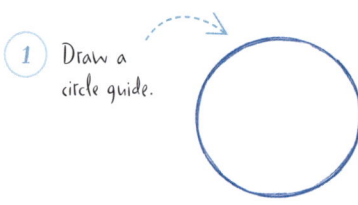

2 Trace a horizontal line across the centre, and a curved, vertical line on the left side of the top half.

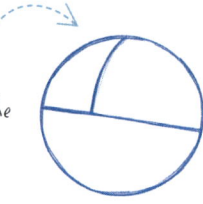

3 Draw a circular muzzle guide.

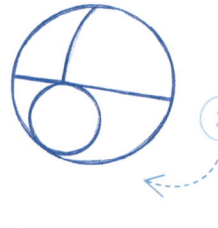

28

4 Add two triangles for the ears.

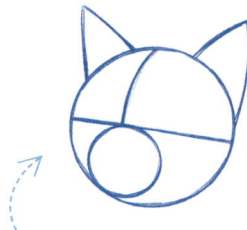

5 Under the circular guideline, draw a large, U-shaped guide for the furry neck.

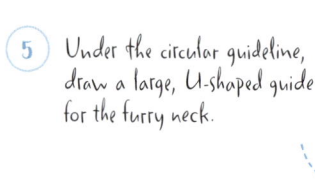

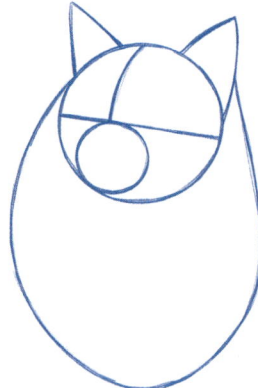

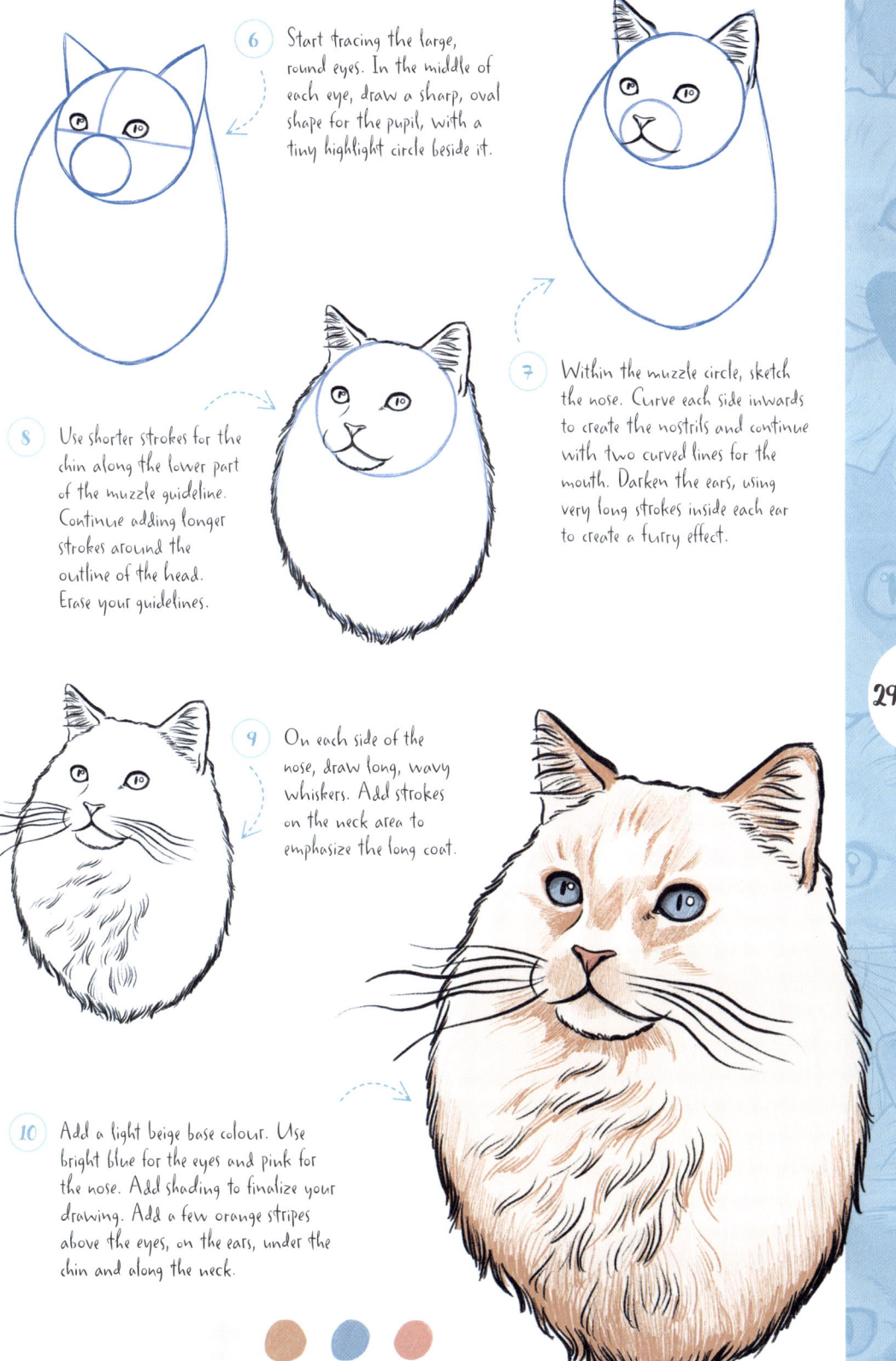

6 Start tracing the large, round eyes. In the middle of each eye, draw a sharp, oval shape for the pupil, with a tiny highlight circle beside it.

7 Within the muzzle circle, sketch the nose. Curve each side inwards to create the nostrils and continue with two curved lines for the mouth. Darken the ears, using very long strokes inside each ear to create a furry effect.

8 Use shorter strokes for the chin along the lower part of the muzzle guideline. Continue adding longer strokes around the outline of the head. Erase your guidelines.

9 On each side of the nose, draw long, wavy whiskers. Add strokes on the neck area to emphasize the long coat.

10 Add a light beige base colour. Use bright blue for the eyes and pink for the nose. Add shading to finalize your drawing. Add a few orange stripes above the eyes, on the ears, under the chin and along the neck.

Faces
Sphynx

The Sphynx's main feature is its lack of a fur coat! This cat is not entirely hairless but is covered with fine, downy hair, like a peach skin.

(1) Draw a circle guide.

(2) Trace a straight, horizontal line across the centre and a straight, vertical line through the top half. Add a rectangular muzzle guide.

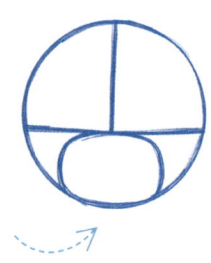

(3) Add two angular shapes for the ears, at least as long as the head's diameter.

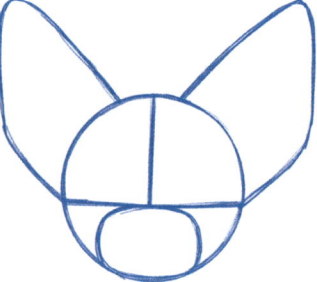

(4) Trace the round, big eyes. In the middle of each eye, draw an almond shape for the pupil with a tiny highlight circle beside it.

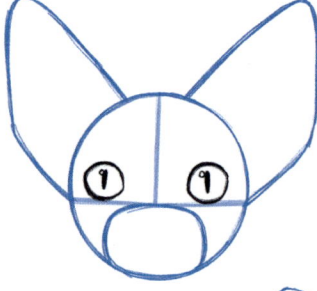

(5) Within the muzzle guideline, sketch the nose. Curve each side inwards to create the nostrils. Under the nose, draw a line that splits into two and curves to the left and right for the mouth.

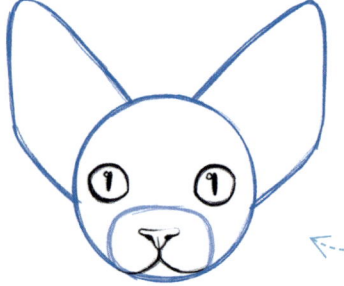

6 Draw the ears with straight lines to avoid the look of fur.

7 Complete the head with neat lines, following the circle guide at first but making the head more triangular than round. The Sphynx has no whiskers or eyelashes.

8 Erase your guidelines. Add some shading around the eyes and ears. The skin is wrinkled on parts of the head.

9 Start colouring with a light pink shade on the ears and around the mouth and nose. Colour one eye green and the other blue.

10 Finalize your drawing with grey on the rest of the head and dark pink for the nose and inner ears.

Snowshoe

Named the Snowshoe because of its white paws, this sweet-natured breed
has a round, full face, striking blue eyes and a muscular build.

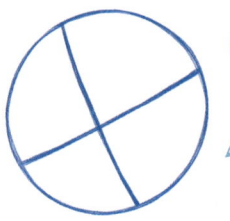

1 Draw a circle guide.
Add two intersecting
lines, tilting to the left.

2 Add two triangular ears
and a circular muzzle guide.

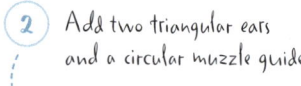

3 On the right side of the
circle guide, draw a long,
vertical line for the wall.
Add a curved line for
the neck.

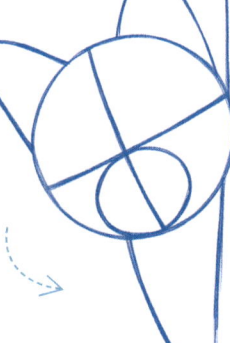

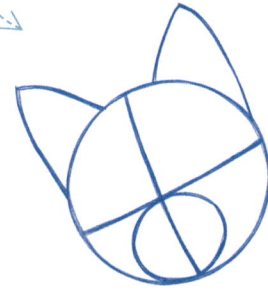

32

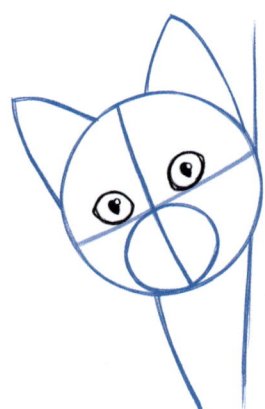

4 Trace the pointed,
fairly large eyes. In
the middle of each
eye, draw the pupil
with a tiny highlight
circle beside it.

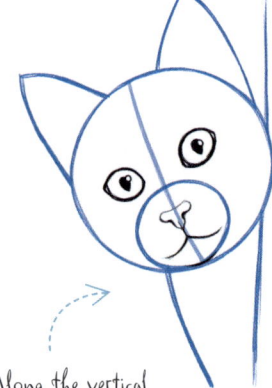

5 Along the vertical
guideline, sketch the nose.
Curve each side inwards
to create the nostrils.
Draw two lines at the
bottom to create the mouth.

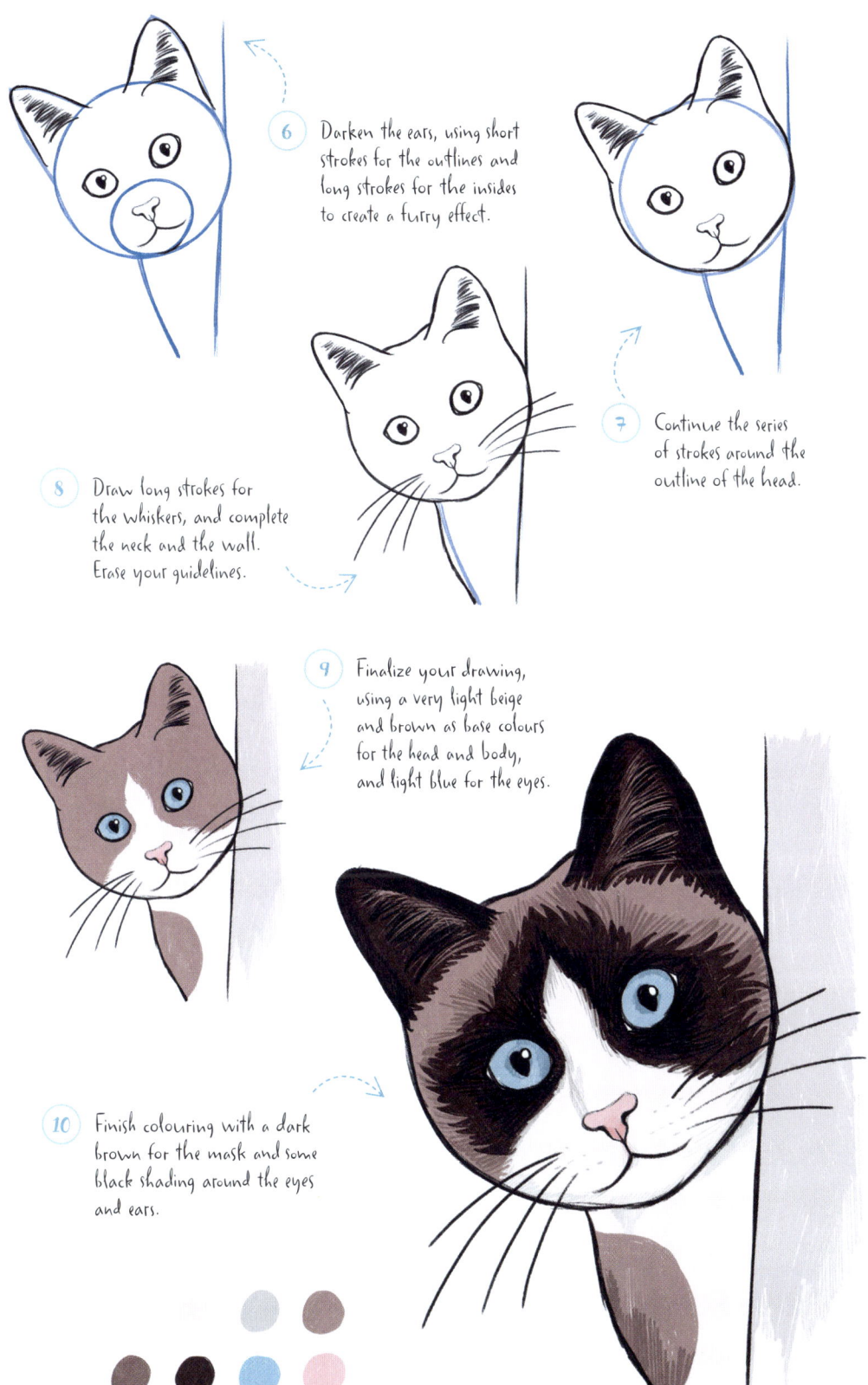

6 Darken the ears, using short strokes for the outlines and long strokes for the insides to create a furry effect.

7 Continue the series of strokes around the outline of the head.

8 Draw long strokes for the whiskers, and complete the neck and the wall. Erase your guidelines.

9 Finalize your drawing, using a very light beige and brown as base colours for the head and body, and light blue for the eyes.

10 Finish colouring with a dark brown for the mask and some black shading around the eyes and ears.

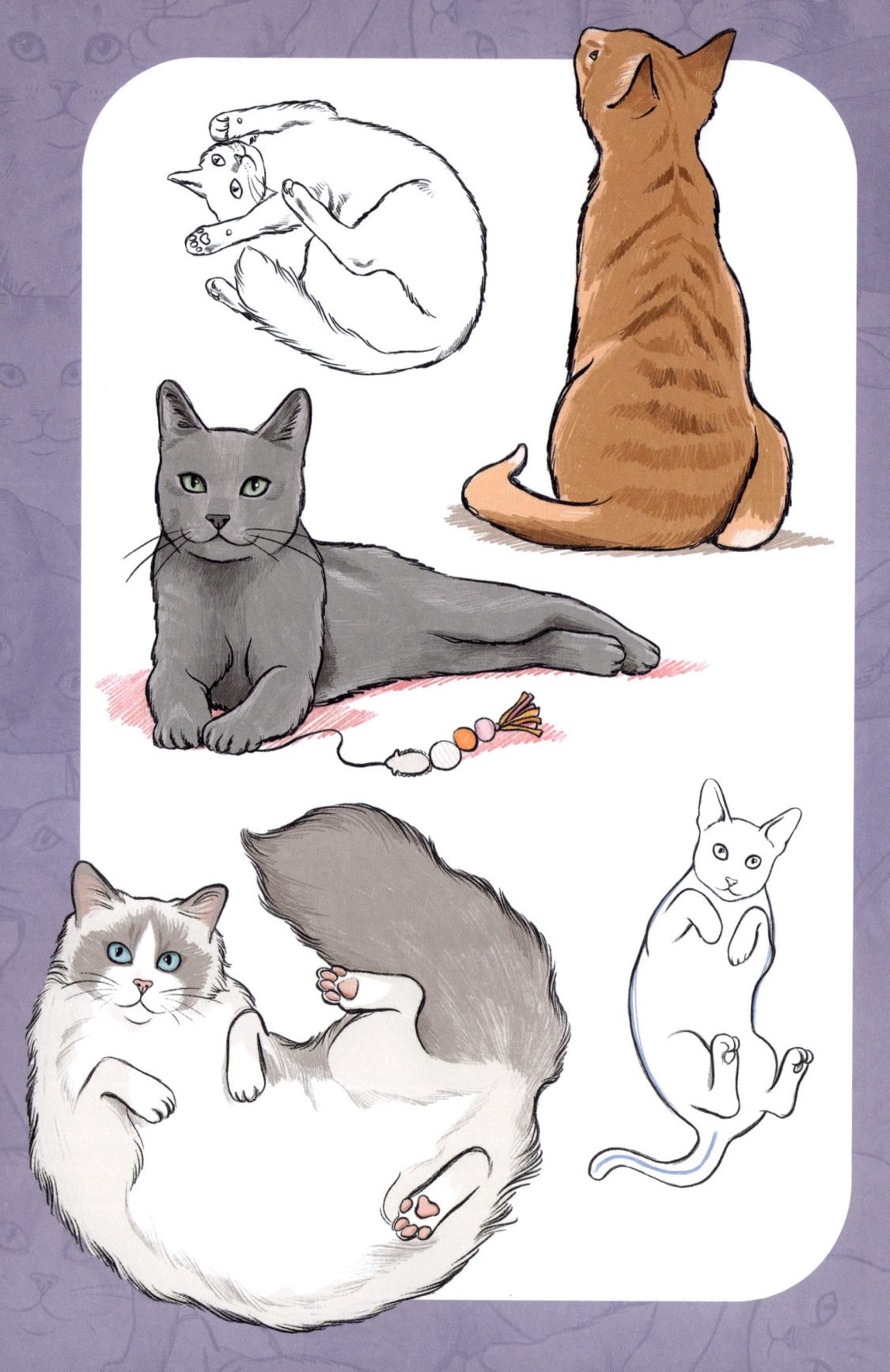

Cats at rest

Sitting: front view

The following felines are drawn in classic sitting poses. When adding curves to connect your sitting cat's body, make your lines wider for a fluffier cat.

1 Draw a circle guide. Trace a horizontal line across the centre and a vertical line through the top half. Add a circular muzzle guide and two triangular ears.

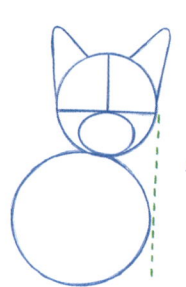

2 Draw a circle slightly to the left of the head and twice its size. The green line shows the circle alignment.

3 Add another circle, a little bigger than the head, with its edge touching the middle circle.

4 Under the chest circle, draw two straight lines for the front legs that go down to the bottom edge of the back circle. At the tip of each line, add an oval paw shape. Add a third oval within the back circle for the rear paw.

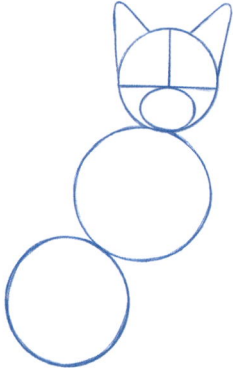

5 Link the body and head circles together using curved lines. Add a curve for the tail.

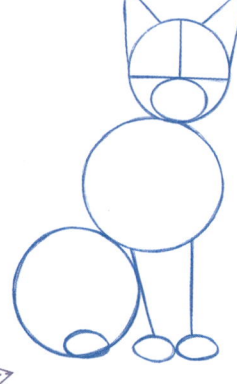

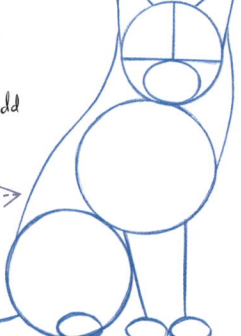

6 Use the initial circle as a guide to add features to the head. Draw the first front leg around the guidelines, making it wider at the top. Add extra strokes on the outer side of the leg for a furry effect. Finish with a few curved lines for the toes.

7 Move on to the second leg, which is partly hidden behind the first. Add the toes with a few curved strokes.

8 Draw the rear paw within the final oval shape.

9 Keep tracing the body. Trace longer strokes towards the bottom part, especially on the tail, to represent the longer hair.

10 Erase your guidelines. Finalize your drawing by adding colour and detail according to the breed.

Sitting: back view

When drawn from the back, cats show off their slender bodies, beautiful markings and long tails as they watch the world go by.

1 Draw a circular guide and add two triangular ears. The central triangle will become the left ear.

2 Add another triangular shape to the top left of the circle as a guide for the muzzle. Draw a large oval shape under – but not touching – the head.

3 Add a semicircle to the lower right, as a guide for the hind leg, which is folded on its side.

4 Link the head and the body with two curved lines to form the neck. Add a short curve for the tail.

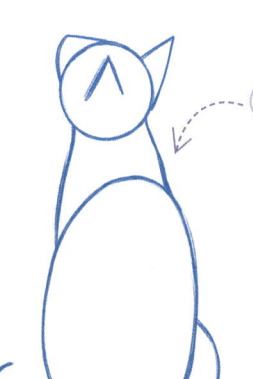

5 Trace the face and ears along the guidelines, and add a tiny triangle for the eye (we can't see much of it from this viewpoint).

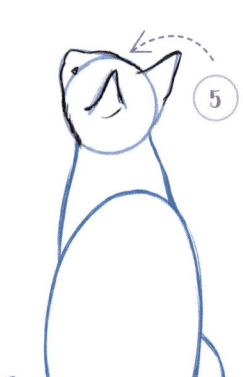

38

6 Keep drawing the body with short strokes, starting from the head and working down.

7 Continue tracing the back.

8 Keep going with the hind leg and tail. Erase your guidelines.

9 Add a light orange base colour.

10 Add some darker markings on the back, with stripes in dark orange and brown tones.

Lying down

Cats love to rest in warm places where they can find peace and quiet.
Sideways sleepers expose their fluffy stomachs as they settle for a snooze.

(1) Draw a circle guide.
Add a curved, vertical
line crossing it, slightly
offset to the left.

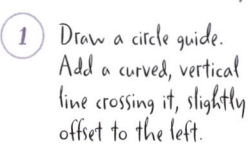

(2) Add an oval
muzzle guide and
two triangular ears
on the right side.

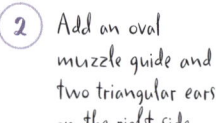

40

(3) Trace the body shape,
adding the front leg on
the left side, with a
circle for the paw.

(4) Add the hind paws,
with two small circles
towards the top-left
corner of the body.
Add a long, curved
tail on the right side.

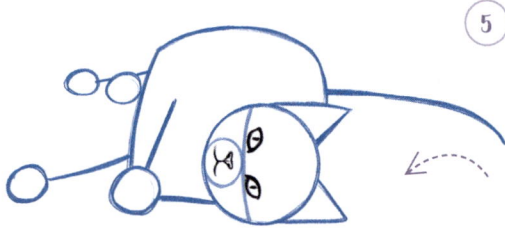

(5) Sketch two almond-shaped eyes,
using the guidelines for placement
and making the corners pointier.
Inside the muzzle, sketch the nose
and finish with two curved lines
for the mouth.

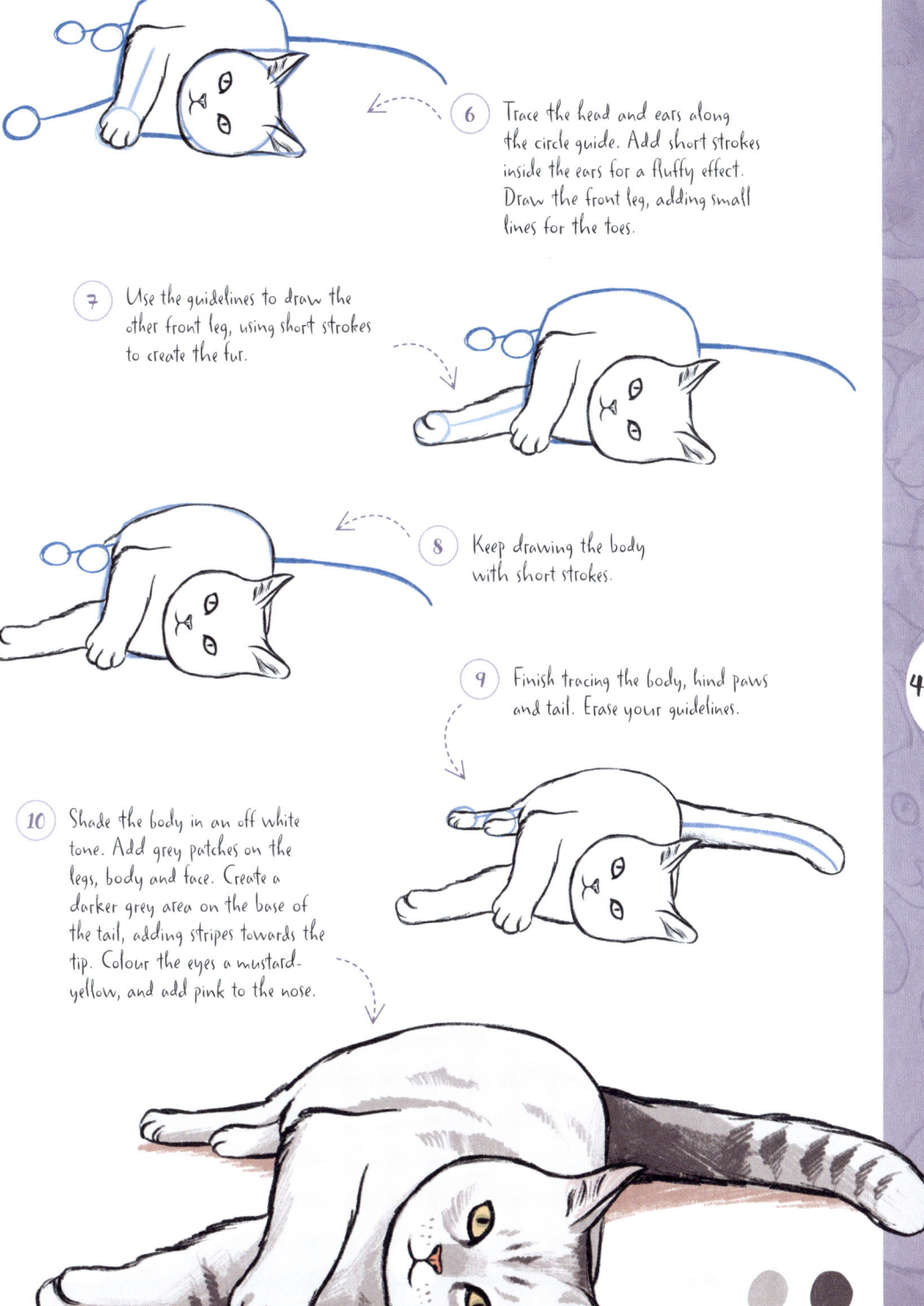

6 Trace the head and ears along
the circle guide. Add short strokes
inside the ears for a fluffy effect.
Draw the front leg, adding small
lines for the toes.

7 Use the guidelines to draw the
other front leg, using short strokes
to create the fur.

8 Keep drawing the body
with short strokes.

9 Finish tracing the body, hind paws
and tail. Erase your guidelines.

10 Shade the body in an off white
tone. Add grey patches on the
legs, body and face. Create a
darker grey area on the base of
the tail, adding stripes towards the
tip. Colour the eyes a mustard-
yellow, and add pink to the nose.

Sleeping

This is a common pose for your feline friend – the average cat enjoys up to sixteen hours of sleep per day! Cats will nap anywhere they feel safe and secure.

1 Draw a circle guide. Add a muzzle shape on the right side and two triangles for ears – one on top of the guideline and another angled beneath it.

2 Draw two circles for the rest of the body.

3 Add curved shapes to represent the front legs, and two oval shapes on the middle and right side of the bottom circle.

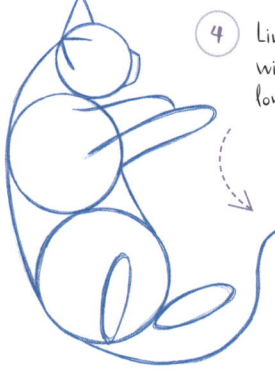

4 Link the three circles together with curved lines and add a long, curved line for the tail.

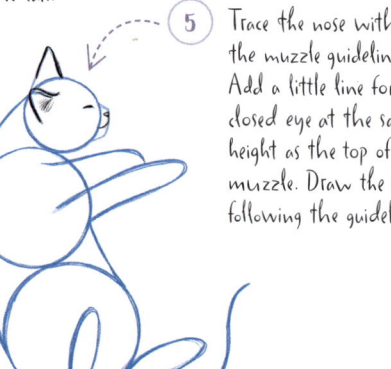

5 Trace the nose within the muzzle guideline. Add a little line for the closed eye at the same height as the top of the muzzle. Draw the ears, following the guidelines.

42

6 Use the guidelines to draw the front and hind legs. Add detail to the visible paws.

7 Continue tracing the head, following the circle guide.

8 Use long strokes to draw the rest of the body and tail.

9 Erase your guidelines. Use a warm yellow base tone, and add another colour around it for the blanket.

10 Add some darker brown stripes to the coat, all over the body, head and tail. Use shades that vary from light to medium brown to emphasize the shadows and highlights.

Classic poses
Curled up

The quintessential cat pose – this content tabby is all curled up
on his favourite rug by the fire, having a well-earned snooze.

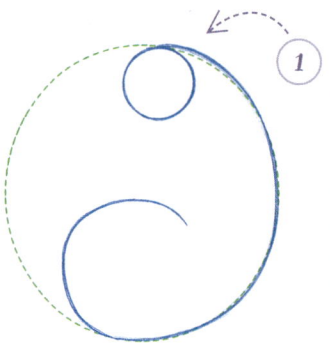

1 Lightly sketch a circular guide for your overall drawing (the dotted green line shows the parts of the circle not used). Starting with a small circle for the head, trace a long curve along the right of the circle, making it curl back on itself towards the middle of the shape.

2 Draw two triangular ears and a long oval at the back of the curve for the tail.

44

3 Add two more ovals as guides for the hind paws.

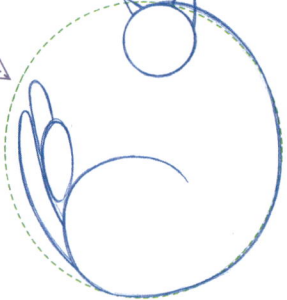

4 Trace the guidelines for the front legs under the head circle.

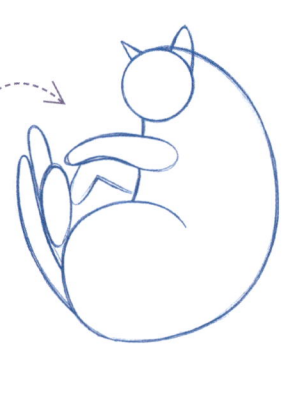

5 Sketch the nose within the head-circle guide, and add a little line for the closed eye.

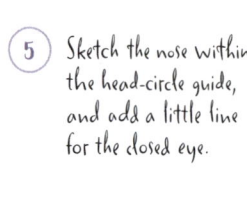

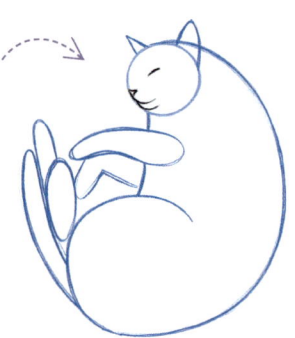

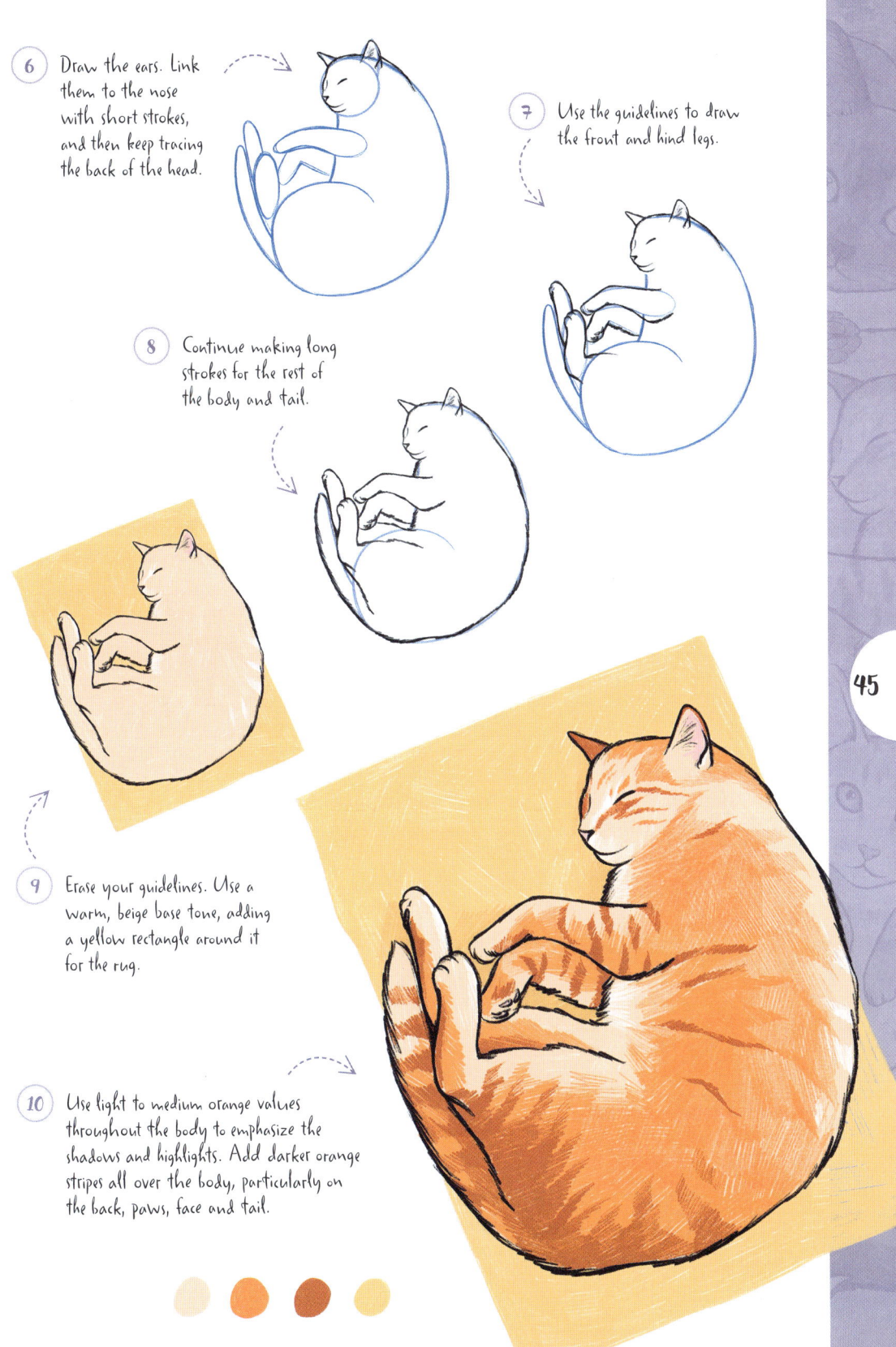

6 Draw the ears. Link them to the nose with short strokes, and then keep tracing the back of the head.

7 Use the guidelines to draw the front and hind legs.

8 Continue making long strokes for the rest of the body and tail.

9 Erase your guidelines. Use a warm, beige base tone, adding a yellow rectangle around it for the rug.

10 Use light to medium orange values throughout the body to emphasize the shadows and highlights. Add darker orange stripes all over the body, particularly on the back, paws, face and tail.

Nebelung

Now you have mastered some restful poses, try it on your favourite breeds. When colouring this Nebelung's long, fluffy coat, use strokes that go in the general direction of the fur.

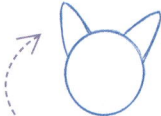

1 Draw a circle guide. Add two triangular ears.

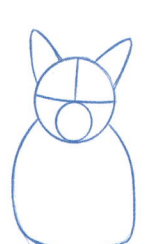

2 Trace a slightly curved, horizontal line across the centre of the head, and a vertical line through the top half. Add a circular muzzle guide. Draw a U-shape for the chest below.

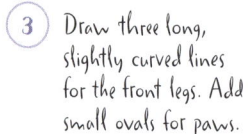

3 Draw three long, slightly curved lines for the front legs. Add small ovals for paws.

4 Draw a long curve from the top right of the torso to the bottom. Add a circle inside for the hind paw. On the left side, draw a shorter curve between the chest and paws.

5 Draw the tail shape. Add curves on each side of the neck.

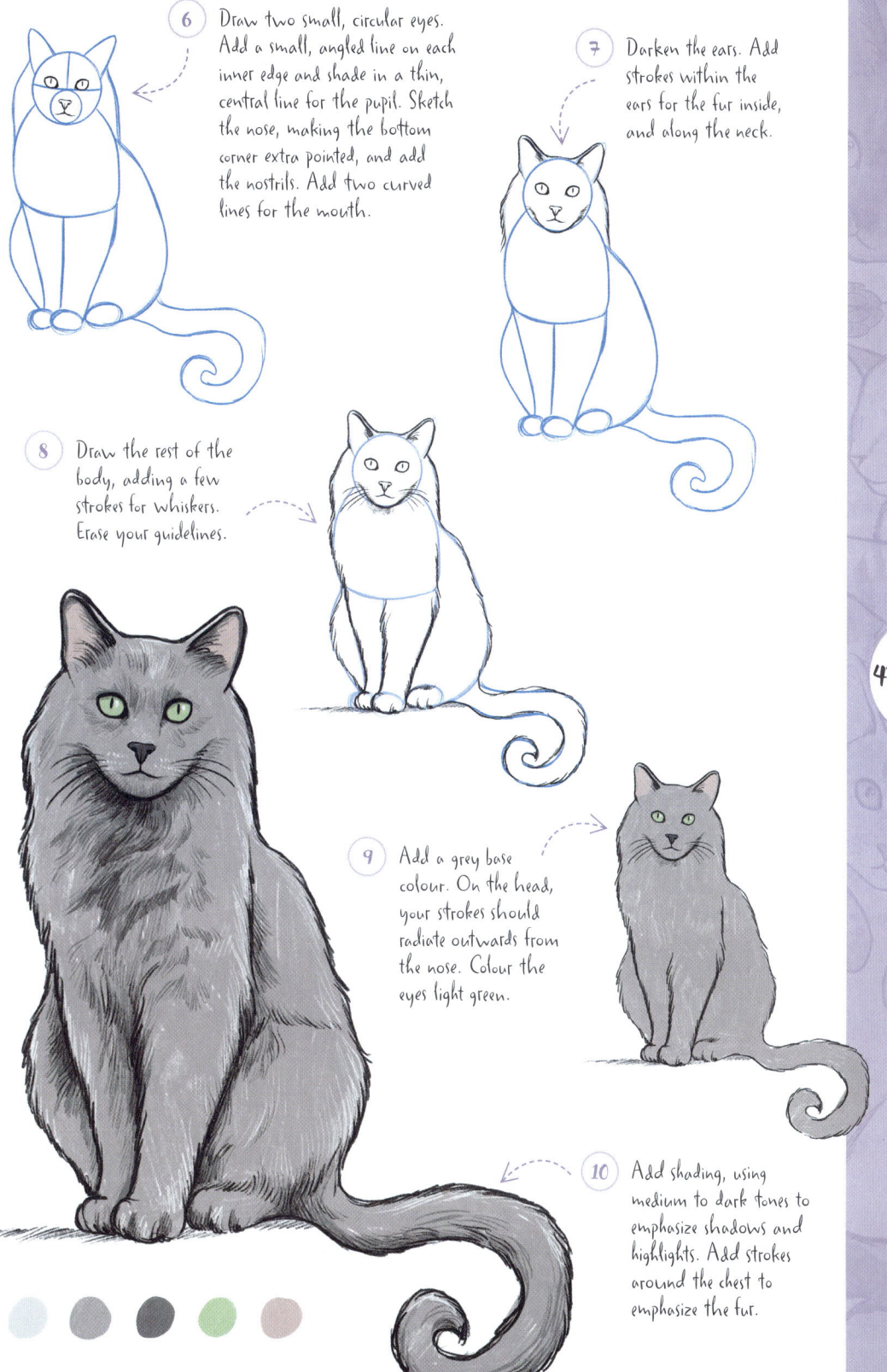

6 Draw two small, circular eyes. Add a small, angled line on each inner edge and shade in a thin, central line for the pupil. Sketch the nose, making the bottom corner extra pointed, and add the nostrils. Add two curved lines for the mouth.

7 Darken the ears. Add strokes within the ears for the fur inside, and along the neck.

8 Draw the rest of the body, adding a few strokes for whiskers. Erase your guidelines.

9 Add a grey base colour. On the head, your strokes should radiate outwards from the nose. Colour the eyes light green.

10 Add shading, using medium to dark tones to emphasize shadows and highlights. Add strokes around the chest to emphasize the fur.

Persian

The Persian's flowing coat, sweet face, and calm temperament make it the most popular cat breed. Use a rough value when shading the furry coat.

① Draw three circle guides for the body and head.

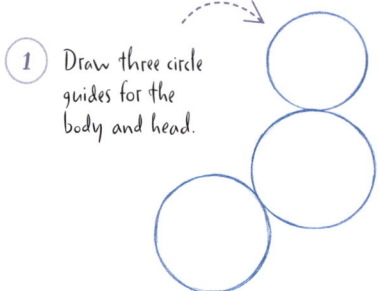

② Draw straight, intersecting guidelines across the head. Add two short, triangular ears and a long, curved tail shape.

③ Draw two slightly curved lines under the chest, as guides for the front legs. Add two ovals for the front paws, and a third oval for the visible back paw.

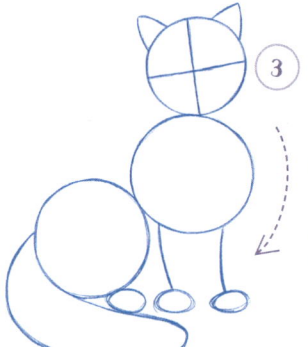

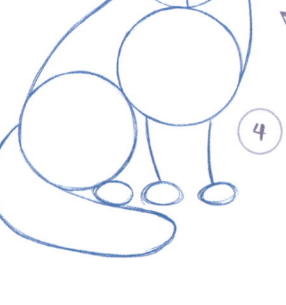

④ Draw curves to link the shapes together. Be generous, as Persians are very round and fluffy.

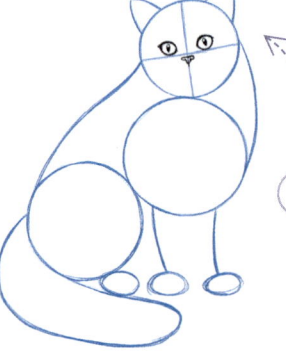

⑤ Sketch two wide, oval eyes using the guidelines for placement. Add a dark line for each pupil and a tiny reflection circle at the top. Where the guides cross, sketch the nose and add nostrils.

6 Below the nose, draw two curved lines for the mouth. Sketch the ears within the triangular guides.

7 Draw the rest of the head and the front legs, using short strokes along the guidelines to create the fur.

8 Add short strokes around the body and longer strokes for the tail outline.

9 Erase your guidelines. Add strokes on the neck and belly for a furry effect.

10 Use light and medium brown tones over the body to emphasize the shadows and highlights, adding strokes in the direction of the fur. Separate each stroke so the white of the paper comes through. Finish with warm, yellow eyes, leaving the highlight circles uncoloured, and a pink nose.

Egyptian Mau

The Mau, which takes its name from the Egyptian word for cat, comes in three colours: silver with charcoal, bronze with dark brown and smoke with black markings.

1. Draw three circle guides for the body and head.

2. Add two triangular ears, a horizontal line crossing the head, and a muzzle shape to the left.

3. Connect the circles with curved lines to create the neck and body.

4. Add three guidelines for the legs (the right hind leg is hidden). Add circular paws and a curved tail.

5. Sketch the triangular eyes using the head guidelines for placement. Add a long oval for each pupil and a tiny highlight circle on top. Sketch a small, triangular nose at the tip of the muzzle.

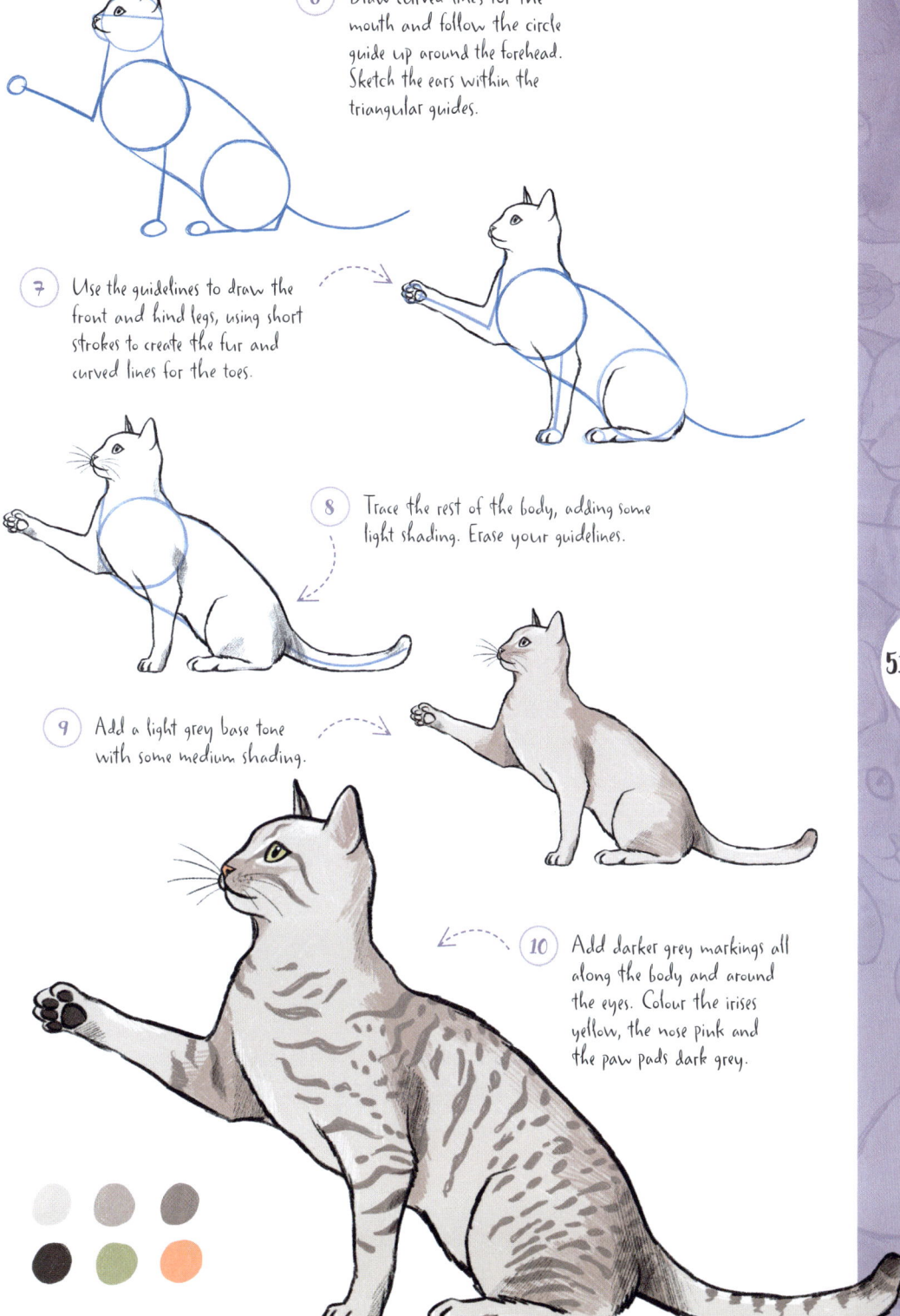

6 Draw curved lines for the mouth and follow the circle guide up around the forehead. Sketch the ears within the triangular guides.

7 Use the guidelines to draw the front and hind legs, using short strokes to create the fur and curved lines for the toes.

8 Trace the rest of the body, adding some light shading. Erase your guidelines.

9 Add a light grey base tone with some medium shading.

10 Add darker grey markings all along the body and around the eyes. Colour the irises yellow, the nose pink and the paw pads dark grey.

Devon Rex

A playful, energetic breed, the Devon Rex has an unusual elf-like appearance, with a triangular head, large, yellow eyes and extremely big ears.

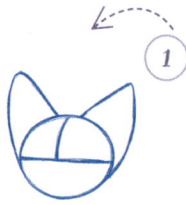

1. Draw an oval guide and two triangular ears. Draw a straight, horizontal line crossing the head and a shorter curve through the top half.

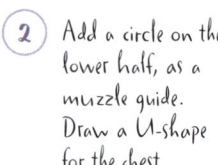

2. Add a circle on the lower half, as a muzzle guide. Draw a U-shape for the chest.

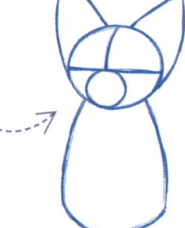

3. Add four lines for the front legs, with semicircular paws.

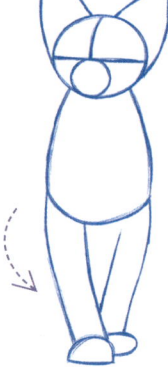

4. Draw a curved line for the body and add a tail shape on the side.

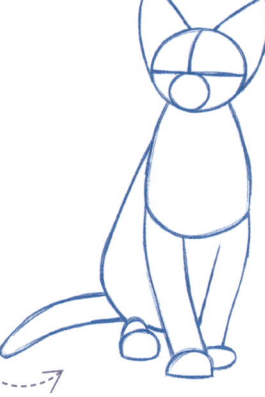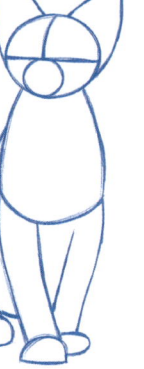

5. Add two semicircular shapes on the left for the visible hind paw.

6 Sketch very large, round eyes, using the guidelines for placement. Add a dark line for each pupil and a tiny highlight circle on top. Sketch a small, triangular nose at the top of the muzzle guideline.

7 Draw some curved lines for the mouth under the nose. Sketch the ears within the triangular guides, adding lines inside to create the structure.

8 Finish drawing the head, using the initial circle as a rough guide but angling the strokes to make the shape more triangular. Draw the front legs using short strokes to create the fur.

9 Keep going with the hind leg, back and tail. Erase your guidelines.

10 Use a pale pink base colour, and add darker stripes on the forehead and legs. Add pink tones on the nose and ears and bright yellow on the eyes.

53

British Shorthair

British Shorthair cats tend to have a very round head and rounder ears than the standard feline. Their short, dense coats come in many colours.

(1) Draw an oval guide. Add two triangular ears.

(2) Draw intersecting guidelines across the head. Add a smaller horizontal mark just below where the lines meet, as a guide for the nose.

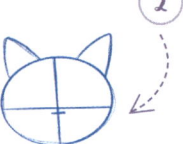

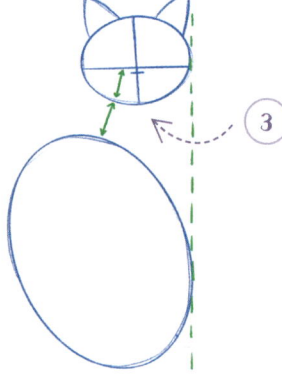

(3) For the body, draw an oval, slightly tilted to the left. The green dashed line shows the alignment between the head and body — the distance between them is equal to half the head's length.

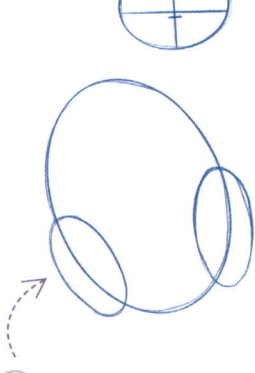

(4) Add two smaller ovals on each side for the hind legs. The left leg is slightly lower than the right.

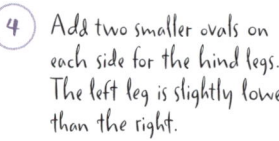

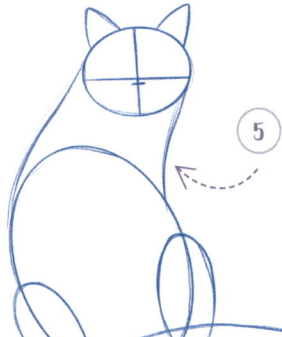

(5) Draw some curves, linking the shapes together, and the tail shape at the bottom right.

54

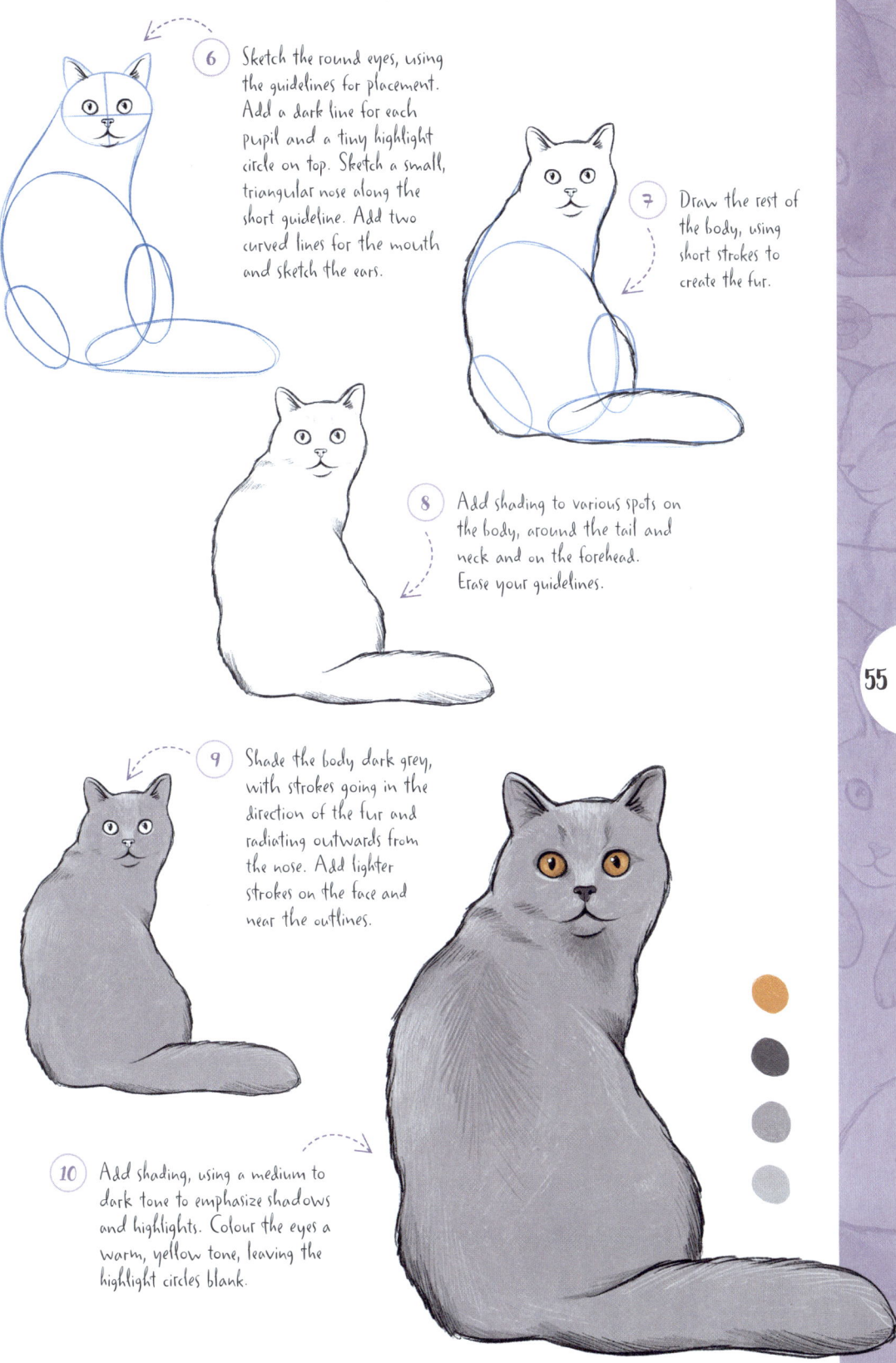

6 Sketch the round eyes, using the guidelines for placement. Add a dark line for each pupil and a tiny highlight circle on top. Sketch a small, triangular nose along the short guideline. Add two curved lines for the mouth and sketch the ears.

7 Draw the rest of the body, using short strokes to create the fur.

8 Add shading to various spots on the body, around the tail and neck and on the forehead. Erase your guidelines.

9 Shade the body dark grey, with strokes going in the direction of the fur and radiating outwards from the nose. Add lighter strokes on the face and near the outlines.

10 Add shading, using a medium to dark tone to emphasize shadows and highlights. Colour the eyes a warm, yellow tone, leaving the highlight circles blank.

Turkish Van

This muscular yet elegant breed has a white body and distinctly coloured head and tail. Its expressive eyes may be coloured amber, blue or one of each.

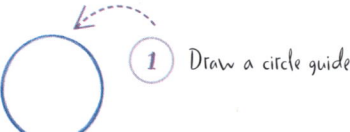

(1) Draw a circle guide.

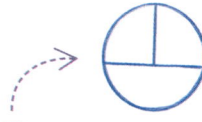

(2) Draw a horizontal line crossing the head, and a vertical line through the top half.

(3) Add two triangular ears, and a circle on the lower half as a muzzle guide.

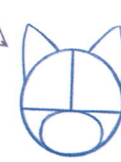

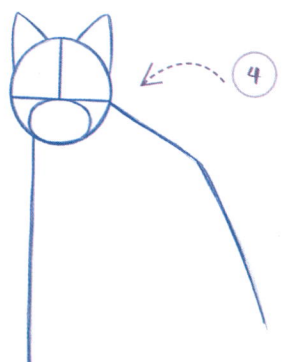

(4) Start drawing the body guidelines. One starts from the right of the head and bends down halfway; the other is a straight, vertical line from the corner of the muzzle.

(5) Finish tracing the guidelines. Add a long, oval tail and two curved lines on each side of the head for the furry neck.

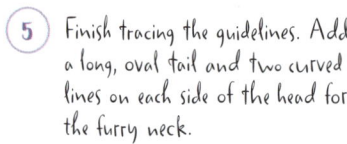

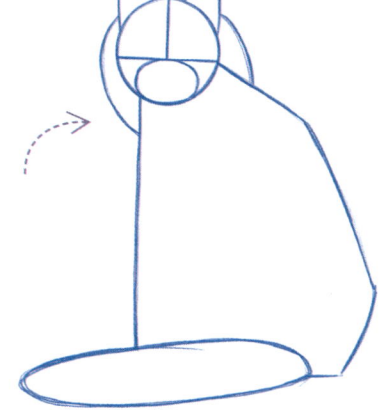

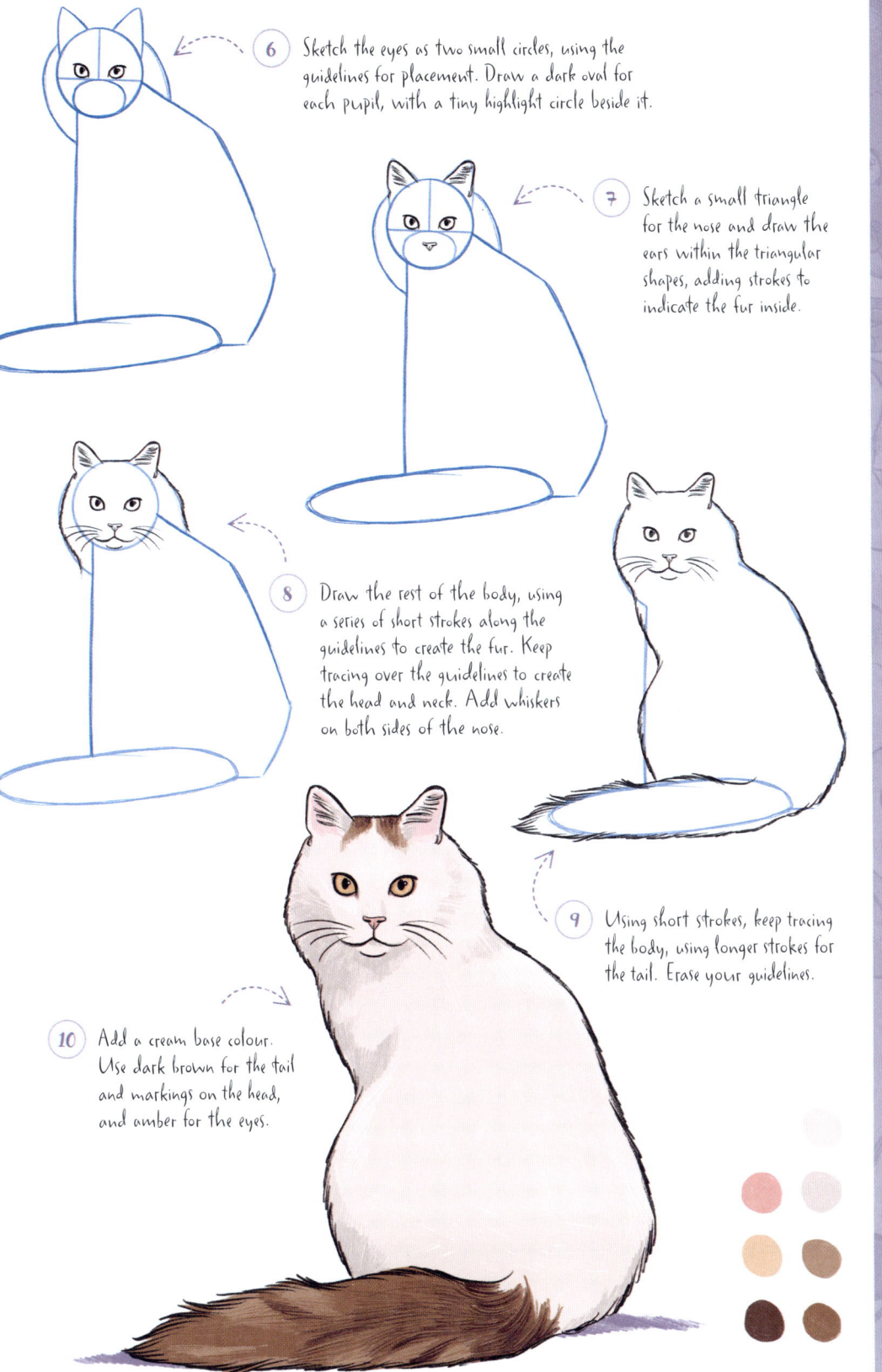

6 Sketch the eyes as two small circles, using the guidelines for placement. Draw a dark oval for each pupil, with a tiny highlight circle beside it.

7 Sketch a small triangle for the nose and draw the ears within the triangular shapes, adding strokes to indicate the fur inside.

8 Draw the rest of the body, using a series of short strokes along the guidelines to create the fur. Keep tracing over the guidelines to create the head and neck. Add whiskers on both sides of the nose.

9 Using short strokes, keep tracing the body, using longer strokes for the tail. Erase your guidelines.

10 Add a cream base colour. Use dark brown for the tail and markings on the head, and amber for the eyes.

Siberian

Siberian cats are charismatic and cuddly with a muscular build and barrel-shaped torso. Use shading to create this tree climber's distinctive stripy coat.

1. Draw a circle guide with straight, intersecting guidelines. Add two triangular ears.

2. Draw a small circle for the muzzle and a large, loaf-like oval for the body.

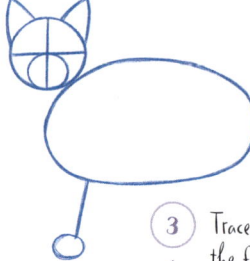

3. Trace a straight line for the front leg, adding a circular paw.

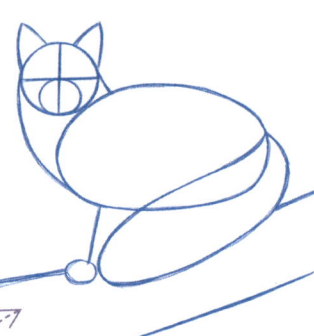

4. Add a large, oval shape for the tail (this covers the other three legs). Add curved lines for the neck and trace the branch shape.

5. Sketch two medium-sized oval eyes, using the guidelines for placement and making the corners pointier. Sketch a small triangle for the nose.

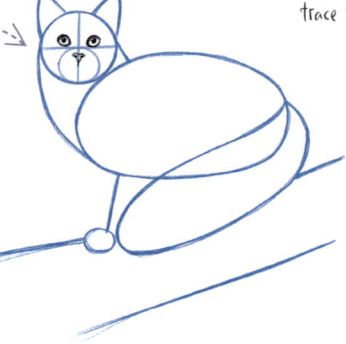

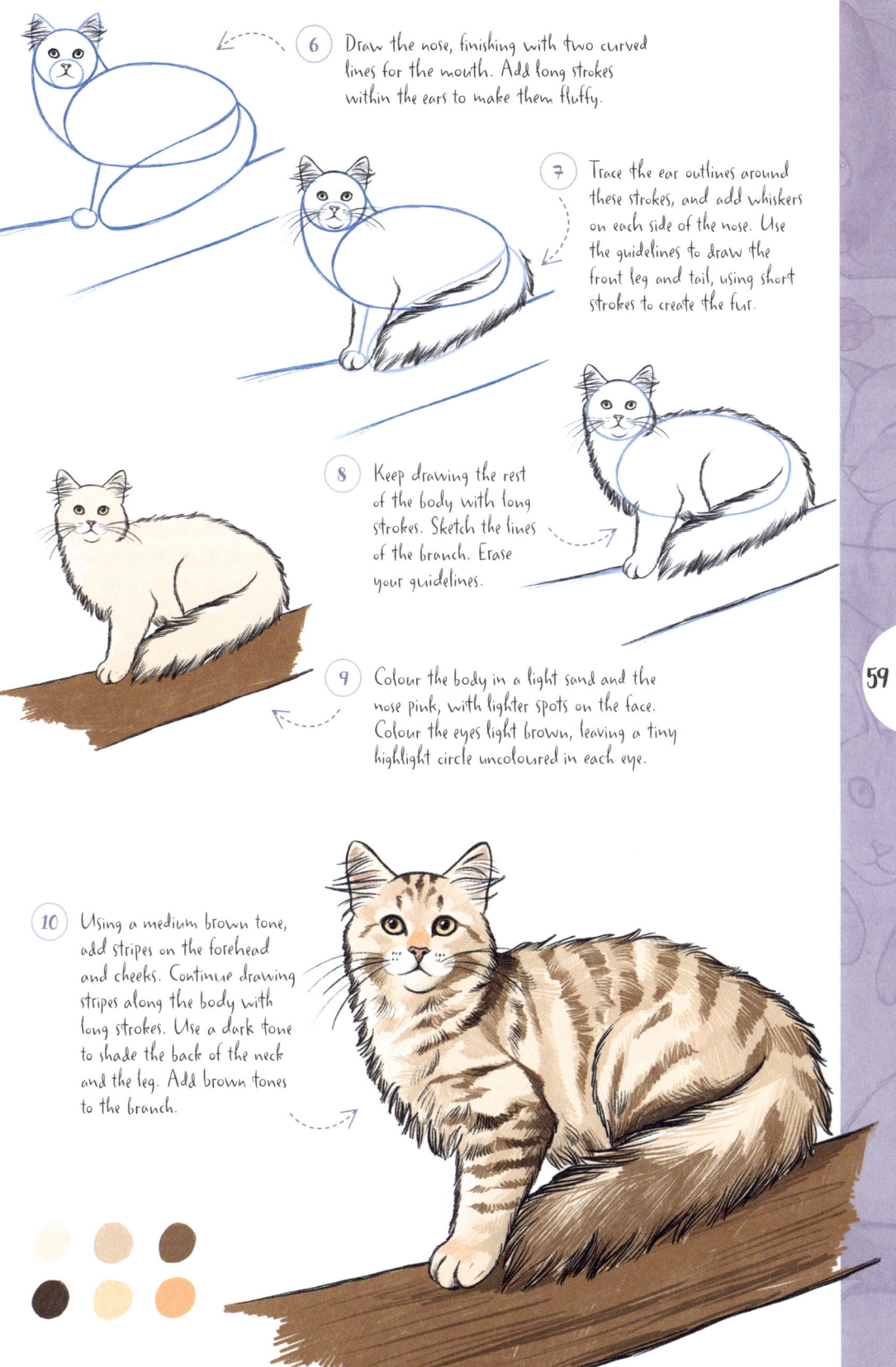

6 Draw the nose, finishing with two curved lines for the mouth. Add long strokes within the ears to make them fluffy.

7 Trace the ear outlines around these strokes, and add whiskers on each side of the nose. Use the guidelines to draw the front leg and tail, using short strokes to create the fur.

8 Keep drawing the rest of the body with long strokes. Sketch the lines of the branch. Erase your guidelines.

9 Colour the body in a light sand and the nose pink, with lighter spots on the face. Colour the eyes light brown, leaving a tiny highlight circle uncoloured in each eye.

10 Using a medium brown tone, add stripes on the forehead and cheeks. Continue drawing stripes along the body with long strokes. Use a dark tone to shade the back of the neck and the leg. Add brown tones to the branch.

59

Bengal

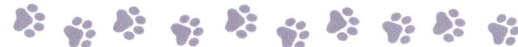

The Bengal's wild appearance is enhanced by its distinctive spotted or marbled coat. This sleek cat has made itself comfortable lying on a branch.

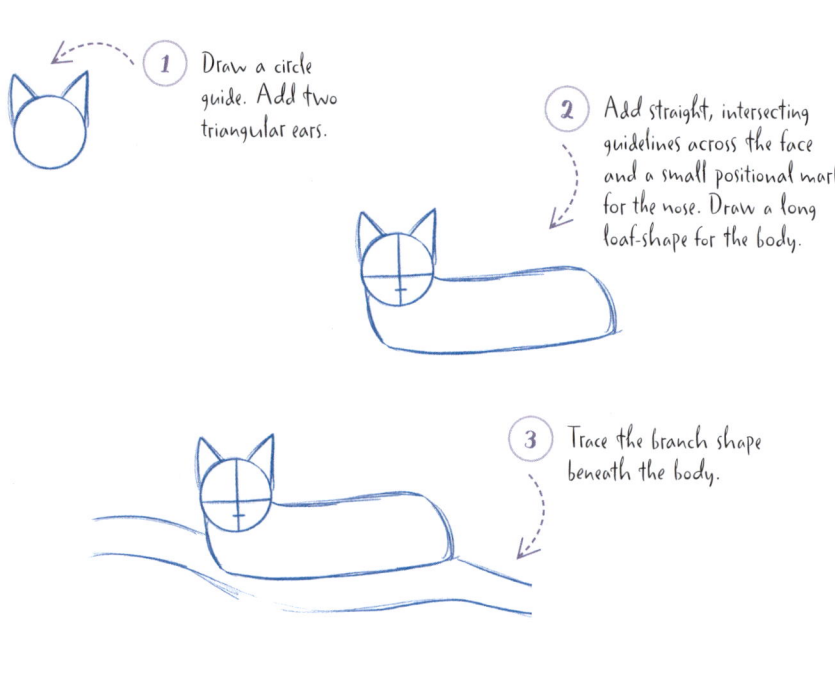

1 Draw a circle guide. Add two triangular ears.

2 Add straight, intersecting guidelines across the face and a small positional mark for the nose. Draw a long loaf-shape for the body.

3 Trace the branch shape beneath the body.

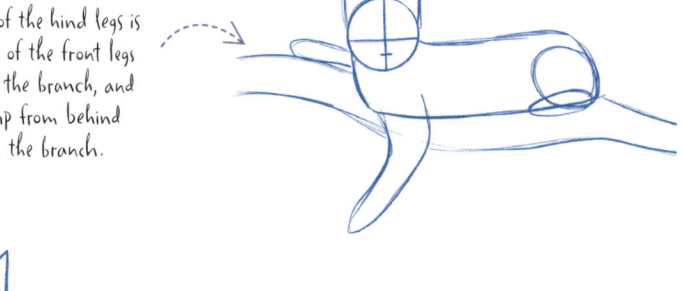

4 Add the legs (one of the hind legs is hidden). Draw one of the front legs hanging in front of the branch, and the other popping up from behind the body, resting on the branch.

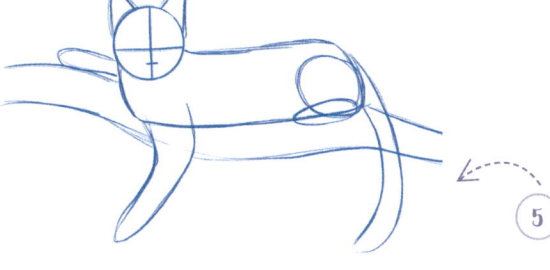

5 Draw the long tail, hanging over the branch.

60

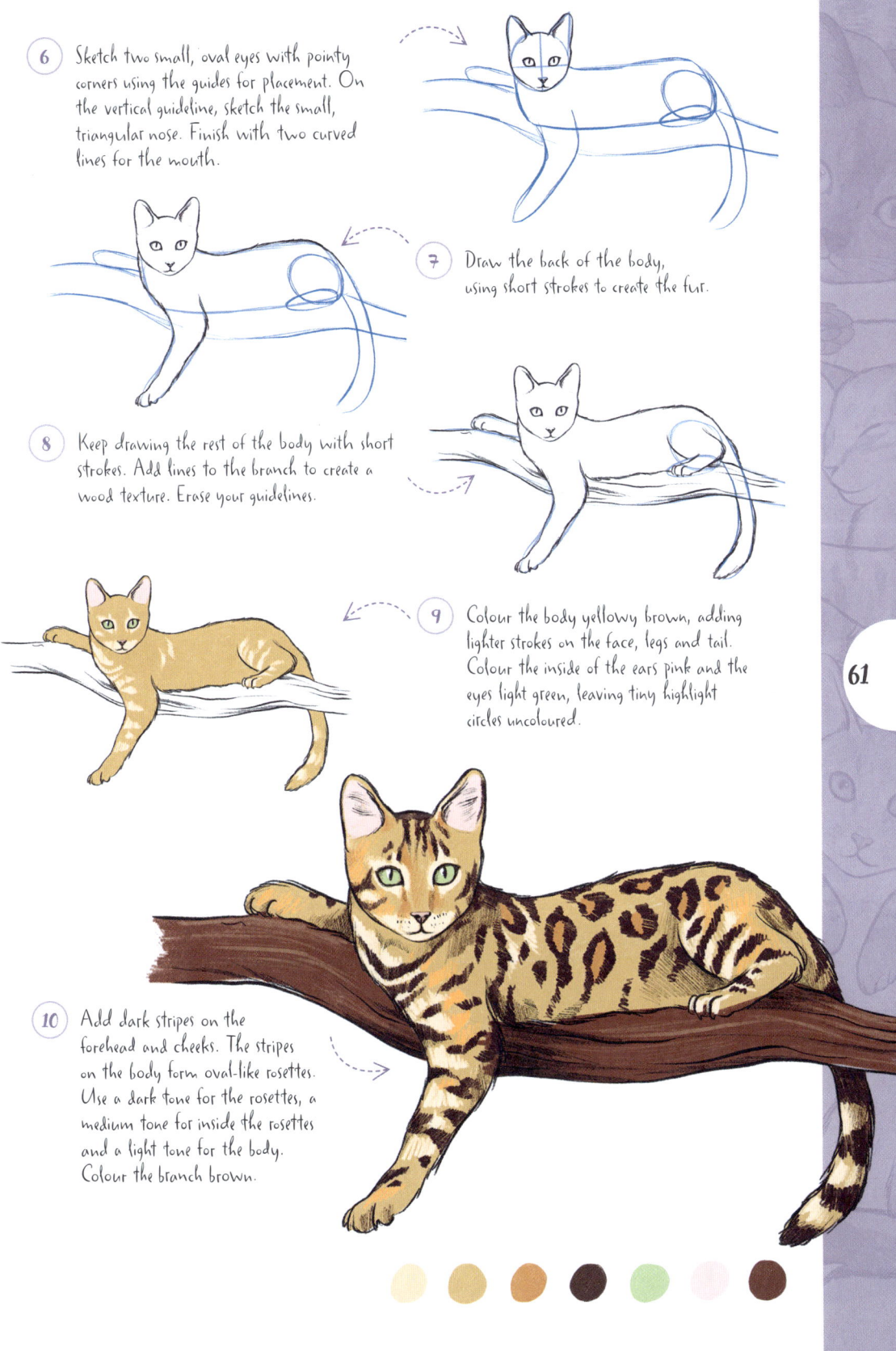

6 Sketch two small, oval eyes with pointy corners using the guides for placement. On the vertical guideline, sketch the small, triangular nose. Finish with two curved lines for the mouth.

7 Draw the back of the body, using short strokes to create the fur.

8 Keep drawing the rest of the body with short strokes. Add lines to the branch to create a wood texture. Erase your guidelines.

9 Colour the body yellowy brown, adding lighter strokes on the face, legs and tail. Colour the inside of the ears pink and the eyes light green, leaving tiny highlight circles uncoloured.

10 Add dark stripes on the forehead and cheeks. The stripes on the body form oval-like rosettes. Use a dark tone for the rosettes, a medium tone for inside the rosettes and a light tone for the body. Colour the branch brown.

Ragdoll

The most laid-back of the domestic cat breeds, this Ragdoll is lying sprawled out on its back – a position that displays trust, as well as relaxation.

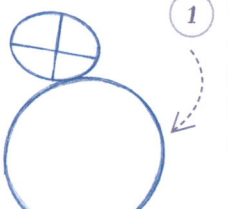

1 Draw a circle guide for the body and a smaller horizontal oval for the head, with two intersecting lines.

2 Draw a narrower vertical oval, touching the main circle. Add two triangular ears.

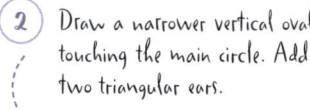

3 Draw four small, oval leg shapes. (As the view is from above, we see the paws more than the legs.)

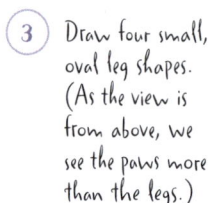

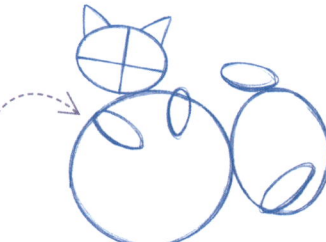

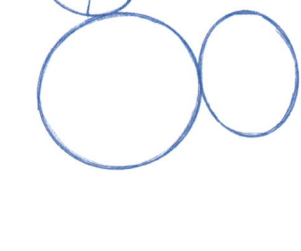

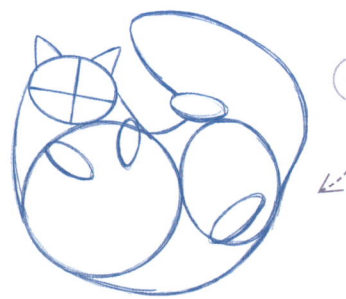

4 Draw curved lines linking the shapes together – be generous with your curves, as Ragdolls are very round and fluffy. Add a large, curved tail shape.

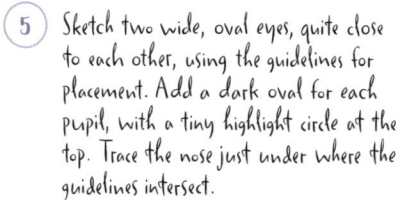

5 Sketch two wide, oval eyes, quite close to each other, using the guidelines for placement. Add a dark oval for each pupil, with a tiny highlight circle at the top. Trace the nose just under where the guidelines intersect.

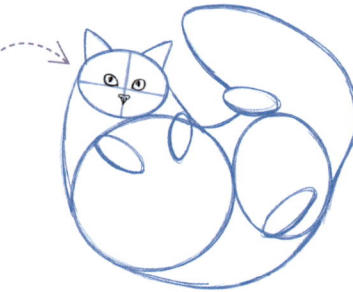

6 Add two curved lines for the mouth and another line for the chin. Sketch the ears within the triangular shapes.

7 Draw the rest of the head and the paws. For the front legs, we will see the top of the paws (a), and for the hind legs, the paw pads will be visible (b).

(a) (b)

8 Draw the body and tail with long strokes.

9 Erase your guidelines. Add a light beige base tone. Keep the face, neck, belly and tip of the paws white.

10 Use light brown tones on the body to emphasize the shadows and highlights. Ragdolls have a darker brown mask around the eyes, with darker brown ears and tail. Colour the inside of the ears, nose and paws pink, and the eyes light blue.

Balinese

Cats roll onto their backs when they are in their most relaxed state.
Balinese look similar to Siamese cats, but with a longer, finer coat.

(1) Draw an oval guide for the head, adding a straight, diagonal line across the oval, a curved line beneath and a circular muzzle guide at the top.

(2) Add a triangular shape for the left ear (the right ear is hidden under the leg). Trace a long curve, beginning on the right side of the head and going back towards the head. Create a long, curved tail shape.

(3) Add pencil shapes to define the hind legs – a large, circular shape for the left thigh and a long oval for the left paw.

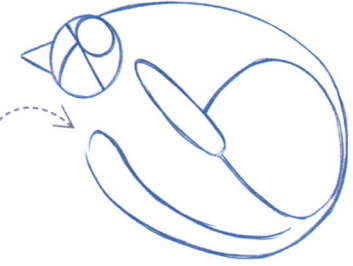

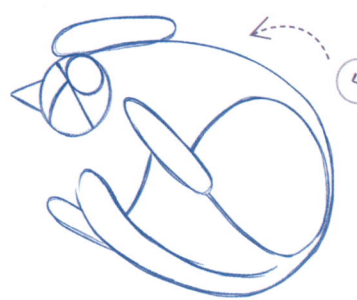

(4) Add the right hind leg shape, popping out from under the tail. Trace the left front paw, with a long, oval guideline next to the head.

(5) Finish tracing the guidelines on the other side of the head, with another long oval for the right front paw.

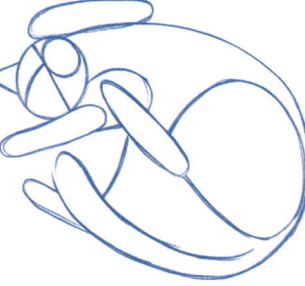

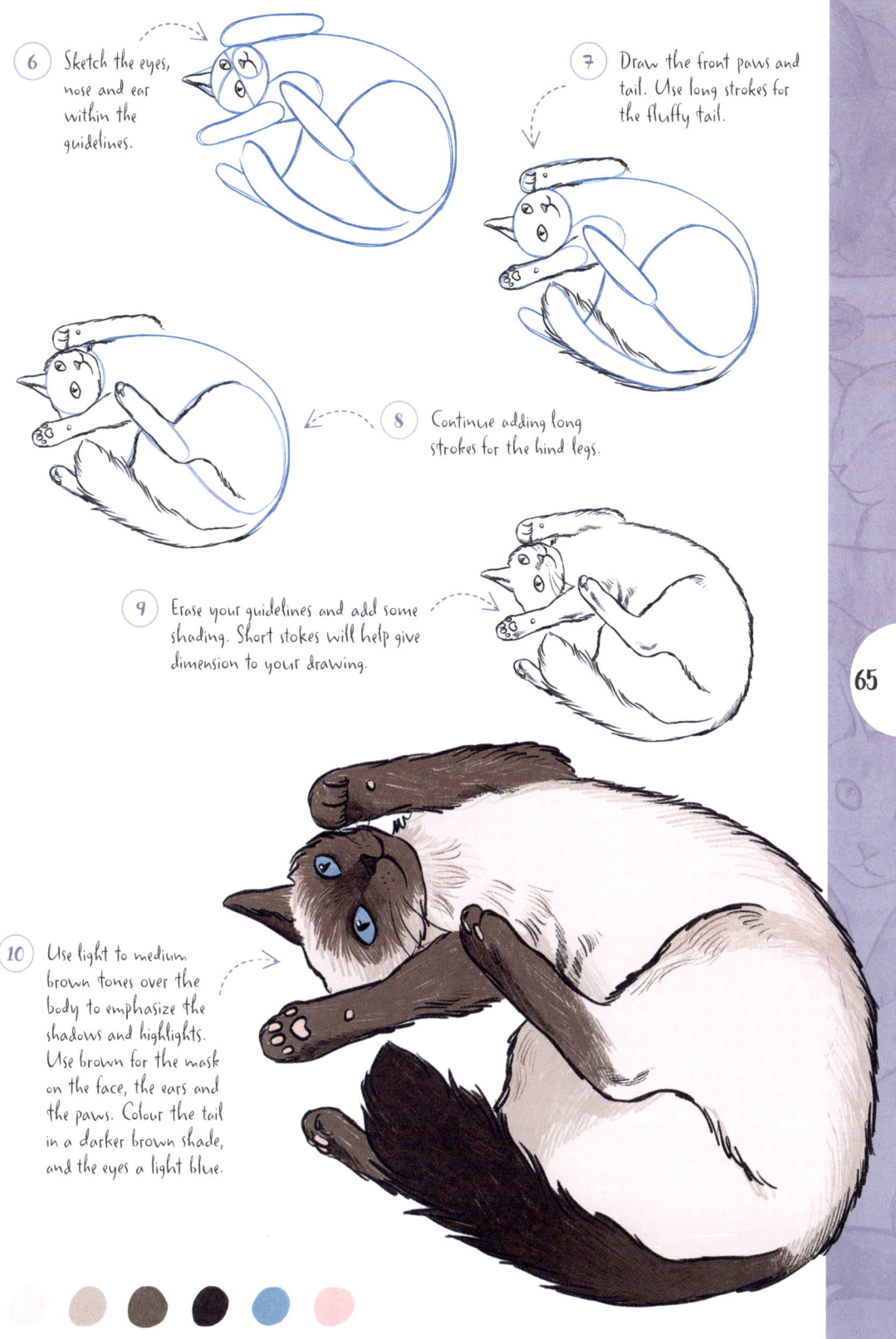

6 Sketch the eyes, nose and ear within the guidelines.

7 Draw the front paws and tail. Use long strokes for the fluffy tail.

8 Continue adding long strokes for the hind legs.

9 Erase your guidelines and add some shading. Short stokes will help give dimension to your drawing.

10 Use light to medium brown tones over the body to emphasize the shadows and highlights. Use brown for the mask on the face, the ears and the paws. Colour the tail in a darker brown shade, and the eyes a light blue.

65

Russian Blue

In addition to their luxurious silvery coat, the Russian Blue's most distinctive features are its brilliant-green eyes and natural 'smile'.

1 Draw a circle guide.

2 Draw a curved, horizontal line across the head with a vertical line in the top half. Add an oval muzzle guide.

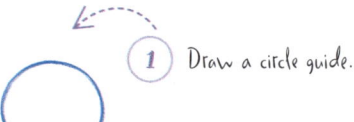

3 Add two triangular ears and two lines to define the chest.

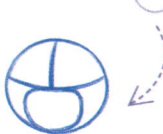

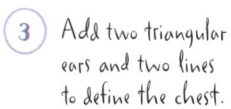

4 Trace two ovals for the front legs, with rounded shapes for paws. Add two horizontal, curved lines for the rest of the body.

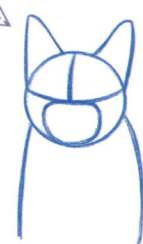

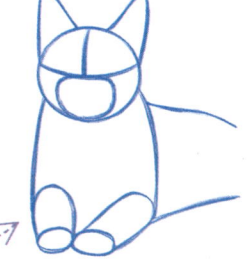

5 Continue the body guidelines to sketch the sprawling back legs.

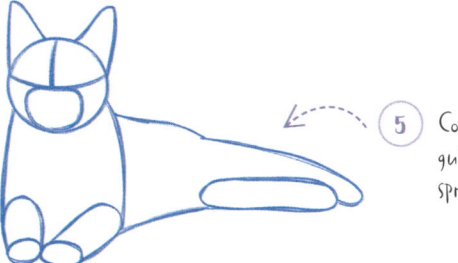

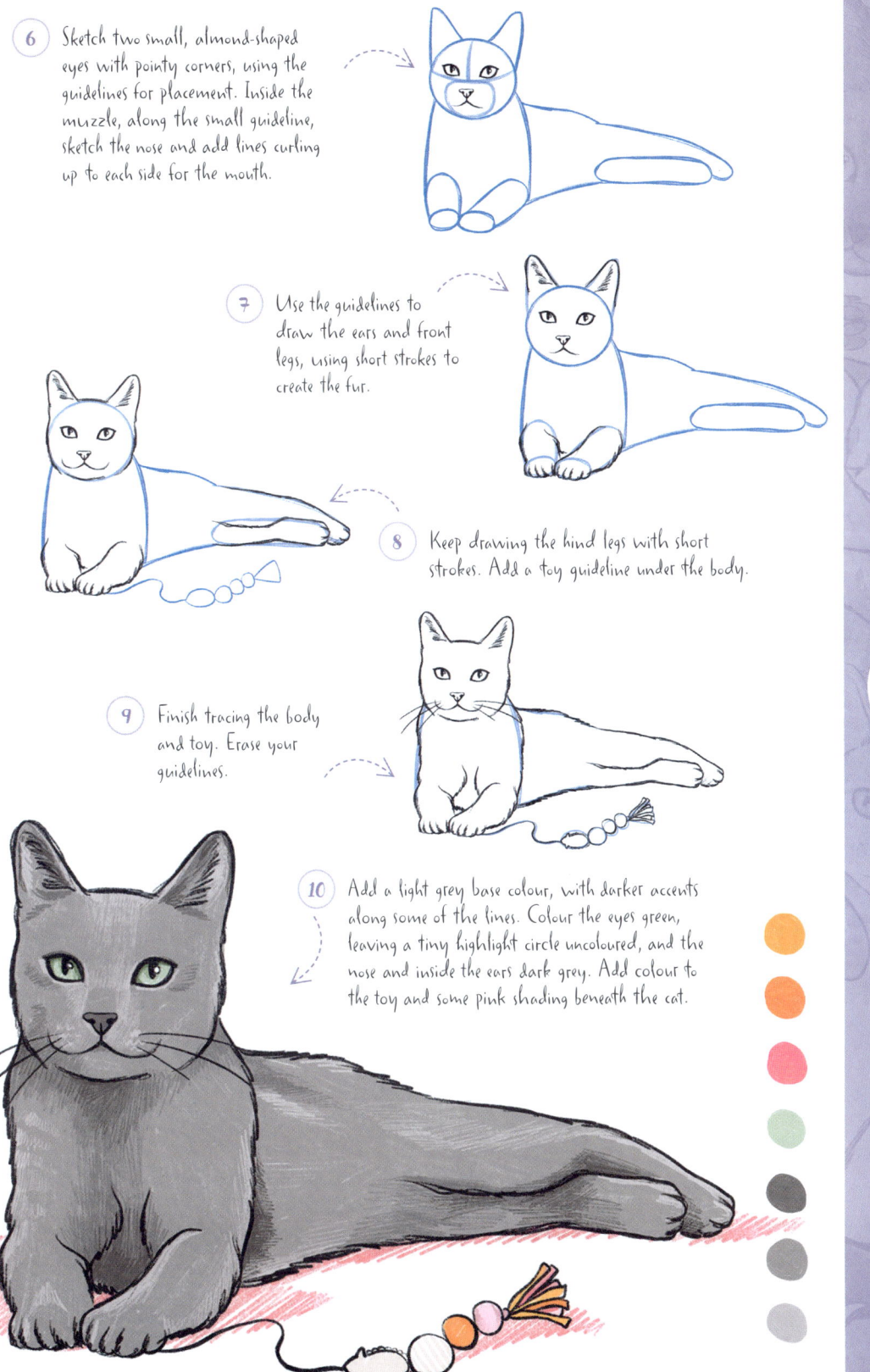

6 Sketch two small, almond-shaped eyes with pointy corners, using the guidelines for placement. Inside the muzzle, along the small guideline, sketch the nose and add lines curling up to each side for the mouth.

7 Use the guidelines to draw the ears and front legs, using short strokes to create the fur.

8 Keep drawing the hind legs with short strokes. Add a toy guideline under the body.

9 Finish tracing the body and toy. Erase your guidelines.

10 Add a light grey base colour, with darker accents along some of the lines. Colour the eyes green, leaving a tiny highlight circle uncoloured, and the nose and inside the ears dark grey. Add colour to the toy and some pink shading beneath the cat.

Burmese

These vocal and affectionate cats are known for their rounded heads and elegant yet well-muscled bodies. Their short, glossy coats come in ten colours.

1. Draw an oval guide for the head, tilted to the right. Add a straight line across the oval, and a shorter line through the top half. Add a smaller, oval muzzle shape.

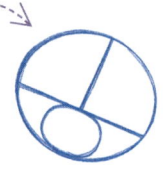

2. Add two triangular ears.

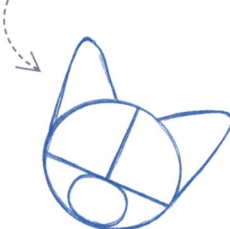

3. Draw the right leg guidelines, bent at a 90-degree angle, with a circular paw shape at the tip. Add the left leg, resting on the ground, with a straight line from the muzzle to the left side.

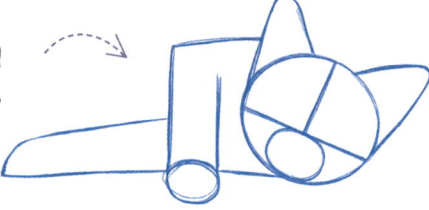

4. Add a curved line for the body, starting from the top of the vertical guideline within the head, going around the ear and ending at the bent elbow.

5. Add the hind legs and tail on each side of the curved body guideline.

68

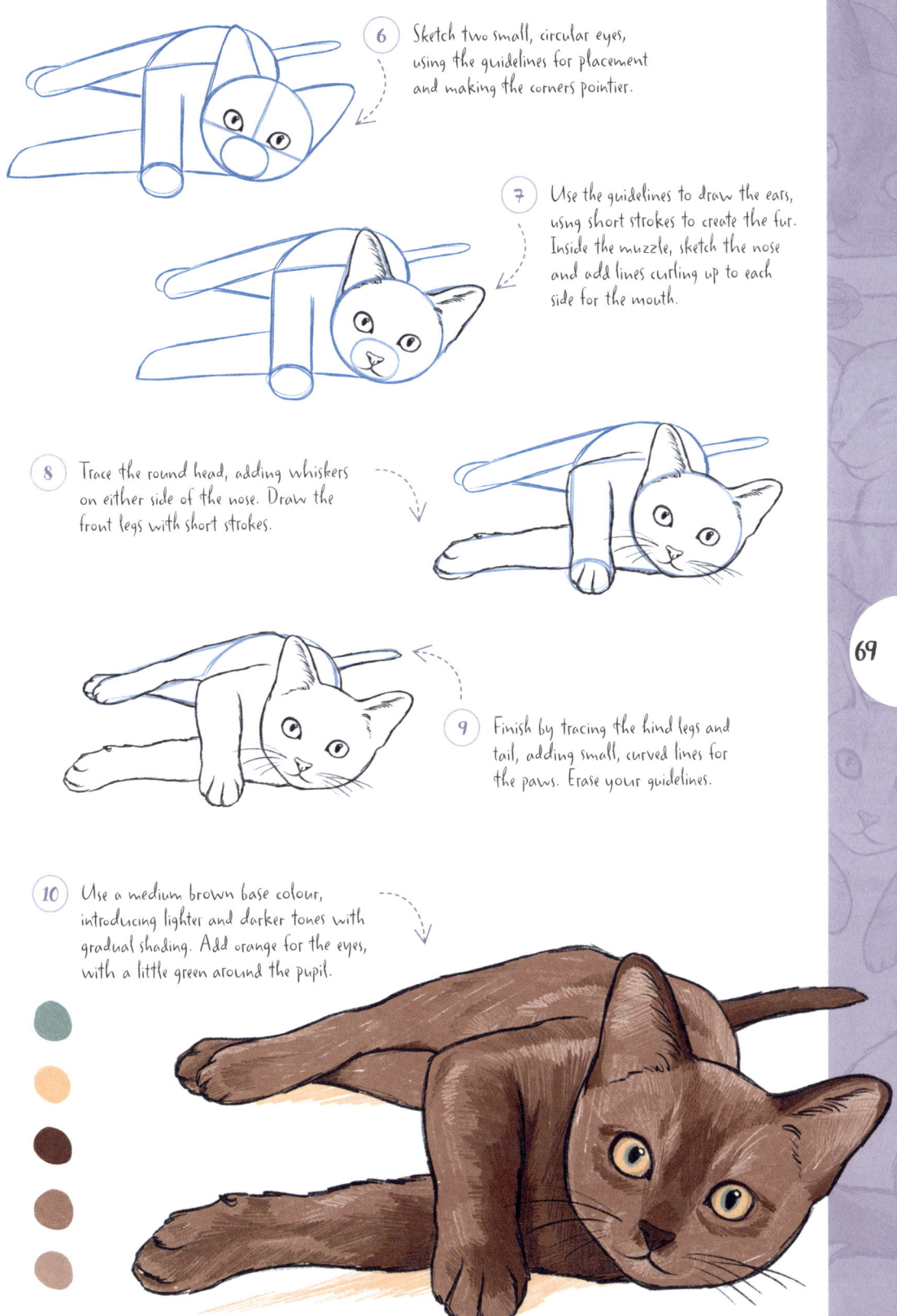

6 Sketch two small, circular eyes, using the guidelines for placement and making the corners pointier.

7 Use the guidelines to draw the ears, using short strokes to create the fur. Inside the muzzle, sketch the nose and add lines curling up to each side for the mouth.

8 Trace the round head, adding whiskers on either side of the nose. Draw the front legs with short strokes.

9 Finish by tracing the hind legs and tail, adding small, curved lines for the paws. Erase your guidelines.

10 Use a medium brown base colour, introducing lighter and darker tones with gradual shading. Add orange for the eyes, with a little green around the pupil.

Colourpoint Shorthair

This long, elegant breed has a short, glossy coat that lies close
to the body. This one is ready for a catnap on the bed.

1 Draw two circle guides
for the head and chest,
quite close to each other
but not touching. Draw
straight, intersecting lines
across the head circle.

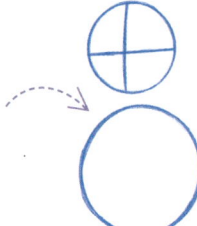

2 Add two triangular
ears. Draw a long,
oval shape for the
rest of the body.

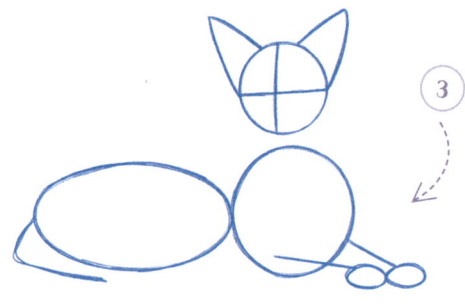

3 Trace two lines for the front
legs, oval front paws and
a bent tail guideline.

4 Add a small circle as a
guide for the hind paw.
Link the shapes with
straight, bent lines.

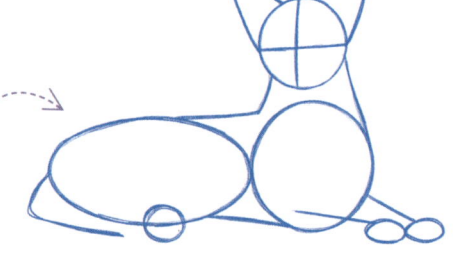

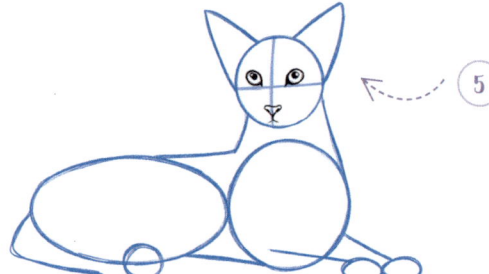

5 Sketch two large, almond-shaped
eyes, using the guidelines for
placement and making the corners
pointier. Towards the bottom of the
vertical guideline, draw the nose.

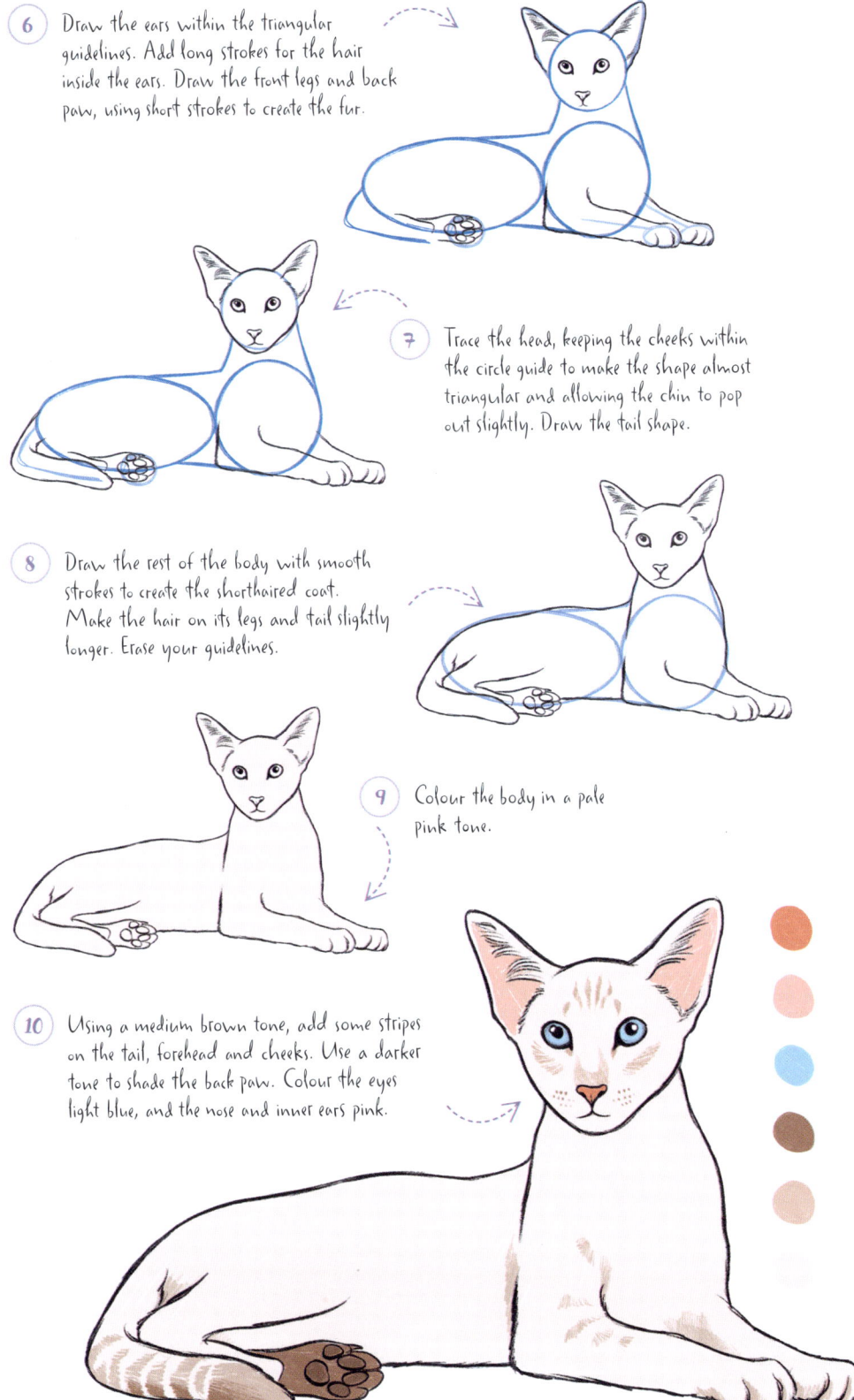

6 Draw the ears within the triangular guidelines. Add long strokes for the hair inside the ears. Draw the front legs and back paw, using short strokes to create the fur.

7 Trace the head, keeping the cheeks within the circle guide to make the shape almost triangular and allowing the chin to pop out slightly. Draw the tail shape.

8 Draw the rest of the body with smooth strokes to create the shorthaired coat. Make the hair on its legs and tail slightly longer. Erase your guidelines.

9 Colour the body in a pale pink tone.

10 Using a medium brown tone, add some stripes on the tail, forehead and cheeks. Use a darker tone to shade the back paw. Colour the eyes light blue, and the nose and inner ears pink.

Savannah

Savannahs are typically black, brown or silver, with black or dark-brown markings. Lying on her back with her paws up, this cat is happy and relaxed.

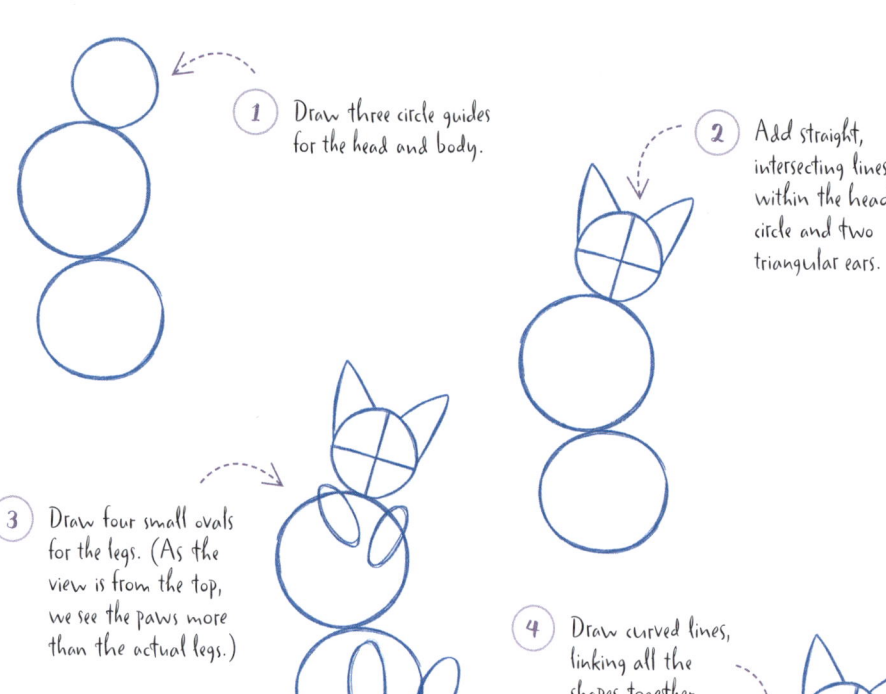

1. Draw three circle guides for the head and body.

2. Add straight, intersecting lines within the head circle and two triangular ears.

3. Draw four small ovals for the legs. (As the view is from the top, we see the paws more than the actual legs.)

4. Draw curved lines, linking all the shapes together, and a wavy tail.

5. Sketch two wide, oval-shaped eyes, using the guidelines for placement. Add a dark oval to each eye for the pupil, with a tiny highlight circle on top. Along the vertical guideline, start tracing the nose and add two short, curved lines for the mouth.

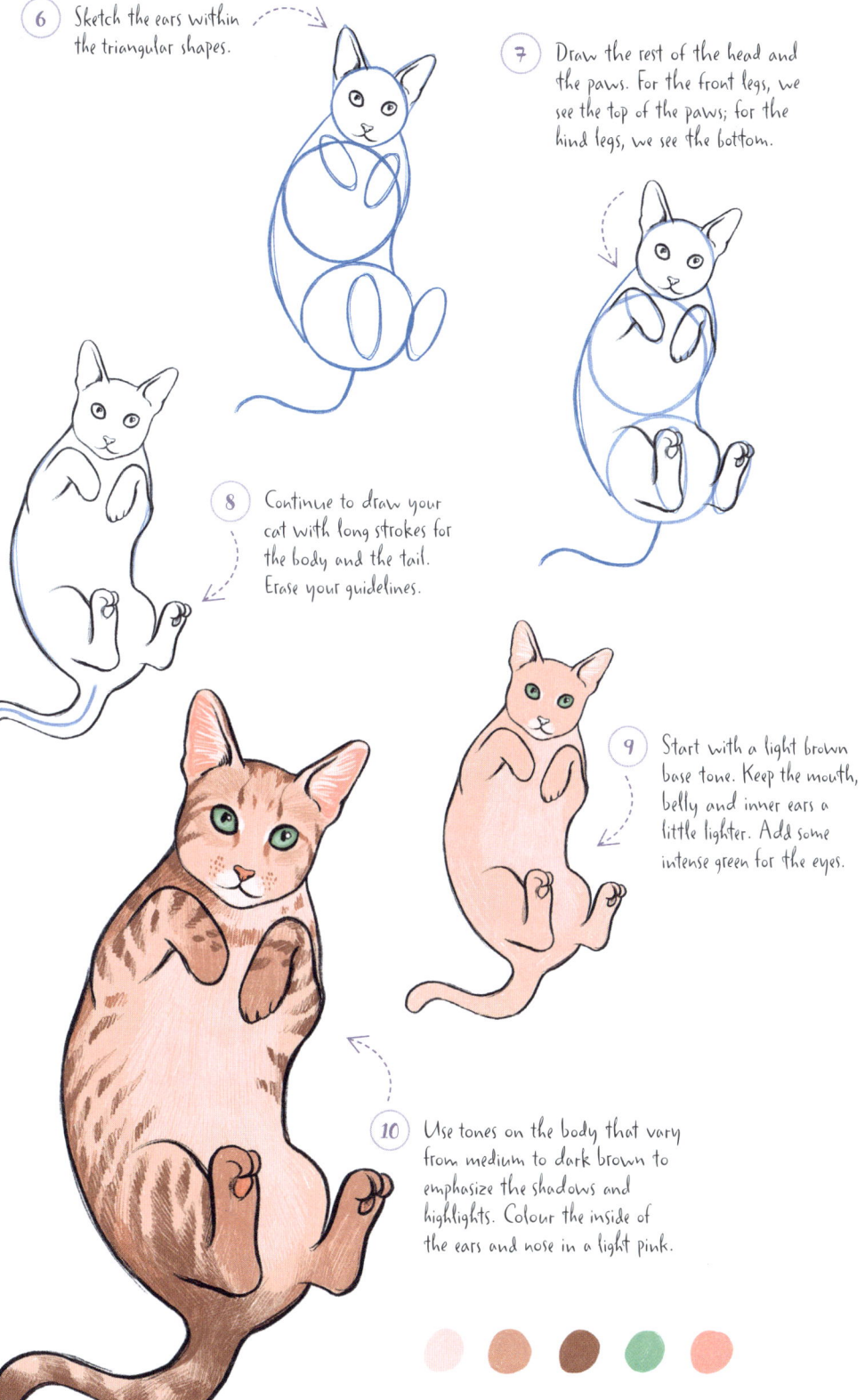

6 Sketch the ears within the triangular shapes.

7 Draw the rest of the head and the paws. For the front legs, we see the top of the paws; for the hind legs, we see the bottom.

8 Continue to draw your cat with long strokes for the body and the tail. Erase your guidelines.

9 Start with a light brown base tone. Keep the mouth, belly and inner ears a little lighter. Add some intense green for the eyes.

10 Use tones on the body that vary from medium to dark brown to emphasize the shadows and highlights. Colour the inside of the ears and nose in a light pink.

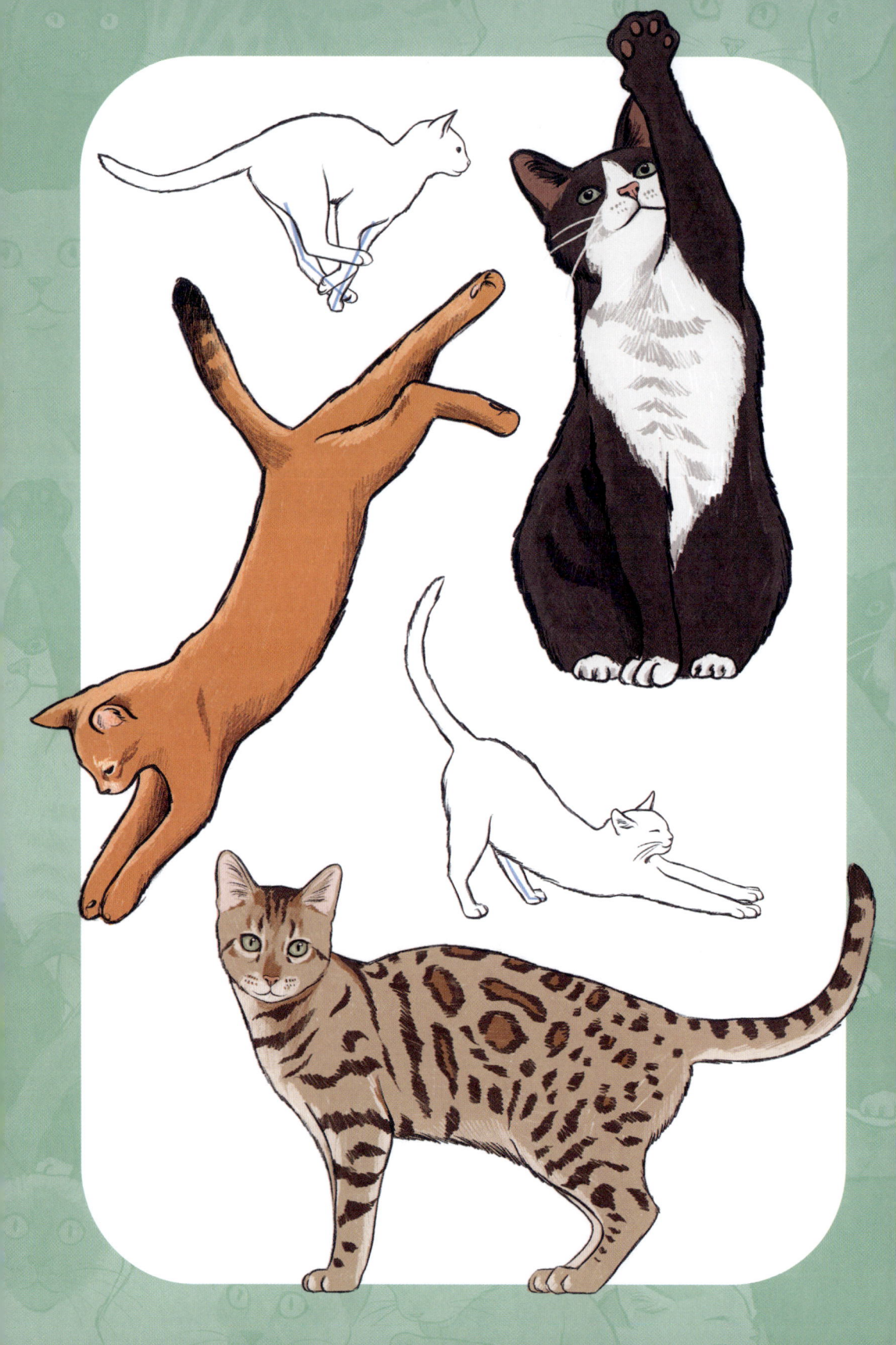

Cats in motion

Classic poses
Standing

In a classic standing pose, this tabby is alert,
watchful and ready to run.

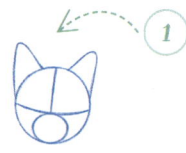

1 Draw a circle guide, with a curved, horizontal guideline and a vertical line through the top section. Add an oval muzzle guide and triangular ears.

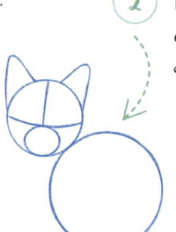

2 Draw another circle, about twice the size of the head.

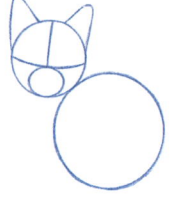

3 Add a third, slightly bigger circle to the right.

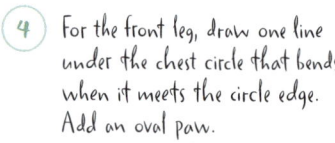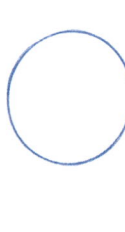

4 For the front leg, draw one line under the chest circle that bends when it meets the circle edge. Add an oval paw.

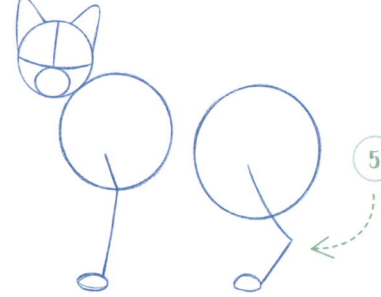

5 Add the hind leg, slightly curving the top towards the right side and keeping the lower part straight. Add an oval paw.

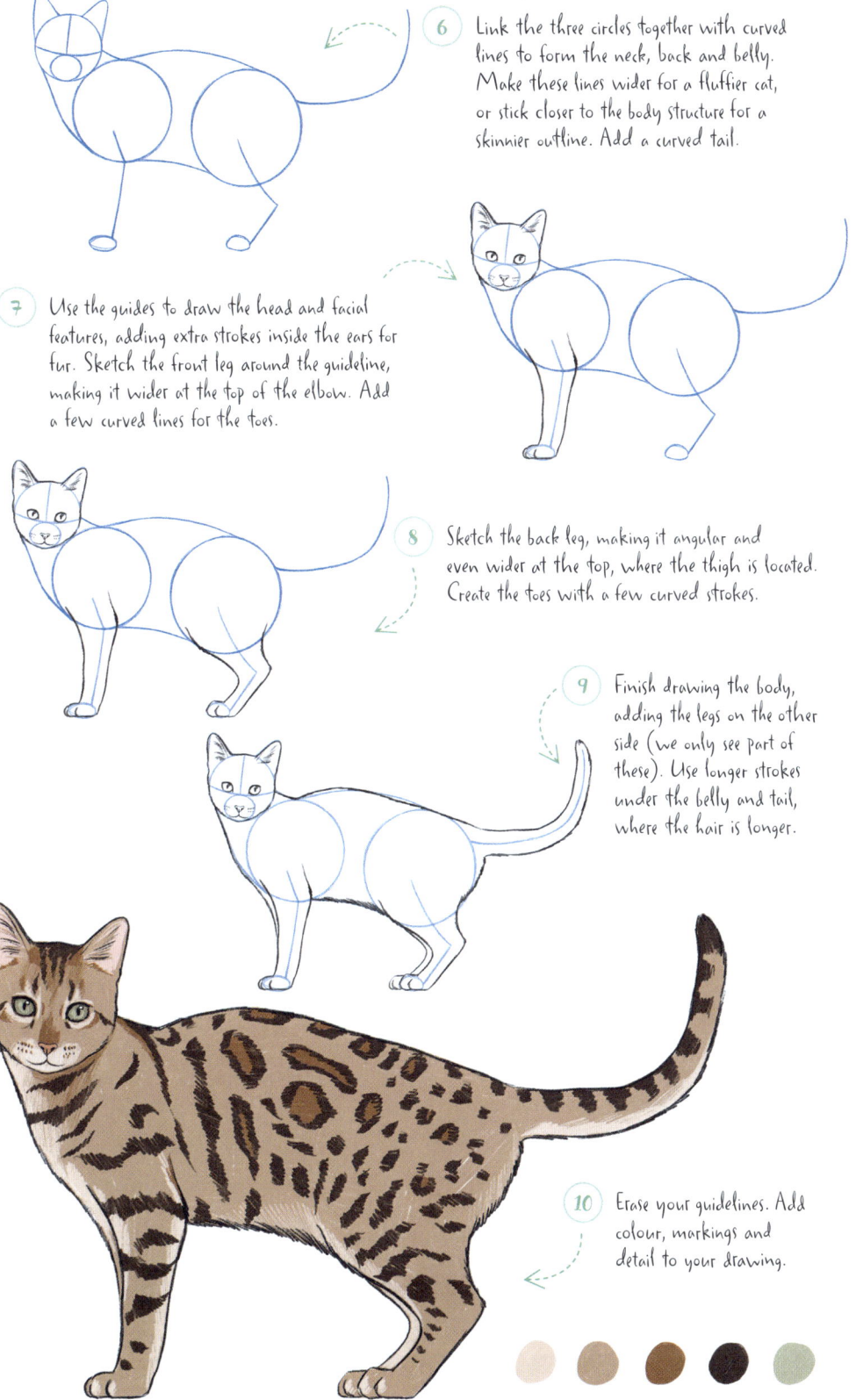

6 Link the three circles together with curved lines to form the neck, back and belly. Make these lines wider for a fluffier cat, or stick closer to the body structure for a skinnier outline. Add a curved tail.

7 Use the guides to draw the head and facial features, adding extra strokes inside the ears for fur. Sketch the front leg around the guideline, making it wider at the top of the elbow. Add a few curved lines for the toes.

8 Sketch the back leg, making it angular and even wider at the top, where the thigh is located. Create the toes with a few curved strokes.

9 Finish drawing the body, adding the legs on the other side (we only see part of these). Use longer strokes under the belly and tail, where the hair is longer.

10 Erase your guidelines. Add colour, markings and detail to your drawing.

Grooming

Cats are typically very clean animals. They can spend as much as fifty per cent of their day grooming themselves, or each other, with their comb-like tongues.

1 Draw a circle guide. Add a horizontal line towards the bottom, and a curved, vertical line to the left of centre. Add a muzzle shape on the lower left side.

2 Add two triangular ears. Draw a large, U-shaped body.

3 Add two guidelines for the front legs, bending the left leg towards the mouth. Add oval-shaped paws.

4 Add two small ovals on the bottom line for the hind paws, and a straight line to the left for the tail.

5 Sketch the closed eyes as two small curves. Within the muzzle guideline, sketch a small triangle for the nose. Draw the ears within the triangular shapes, adding short strokes for the hair inside.

78

6 Draw some curved lines for the mouth, and add whiskers. Finish drawing the head around the circle guide, using short strokes. Draw the left front leg around the guideline, using short strokes to create the fur and adding short, curved lines for toes. Add the tongue.

7 Draw the second front leg, adding short, curved lines for toes. Draw the tail, curled over at the tip.

8 Continue drawing the rest of the body. Erase your guidelines.

9 Use light yellow as a base layer. Add some pink tones to the nose, tongue, and inner ears.

10 Add some shading and darker stripes under the head, on the forehead, and along the legs.

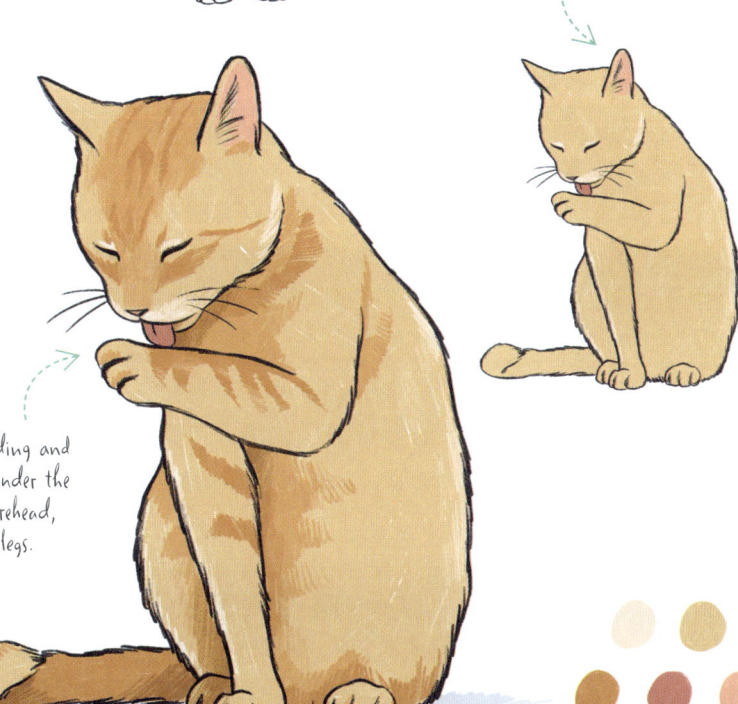

Playing

Cats love to play, and they learn from their activities. Poking, batting and tossing around small toys helps kittens to discover how to deal with prey.

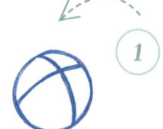

1 Draw a circle guide for the head and add two curved, intersecting guidelines.

2 Add two triangular ears and a larger, circular body shape, leaving a gap below the head.

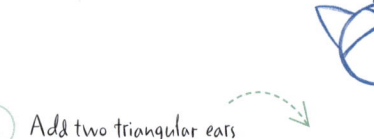

3 Add a slight curve between the head and body circles. Draw the first front leg within the larger circle, adding an oval paw.

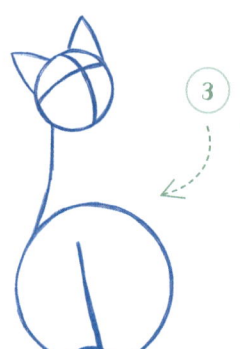

4 Add another curve on the other side of the neck area. Draw the second front leg, which is raised up, and add a circular paw.

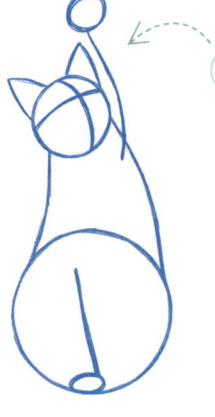

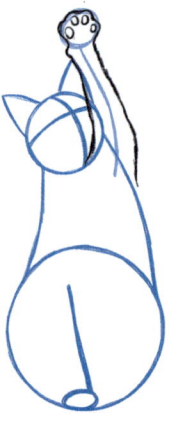

5 Lightly sketch the front leg, which hides part of the face. Add four circles at the bottom of the paw for the pads.

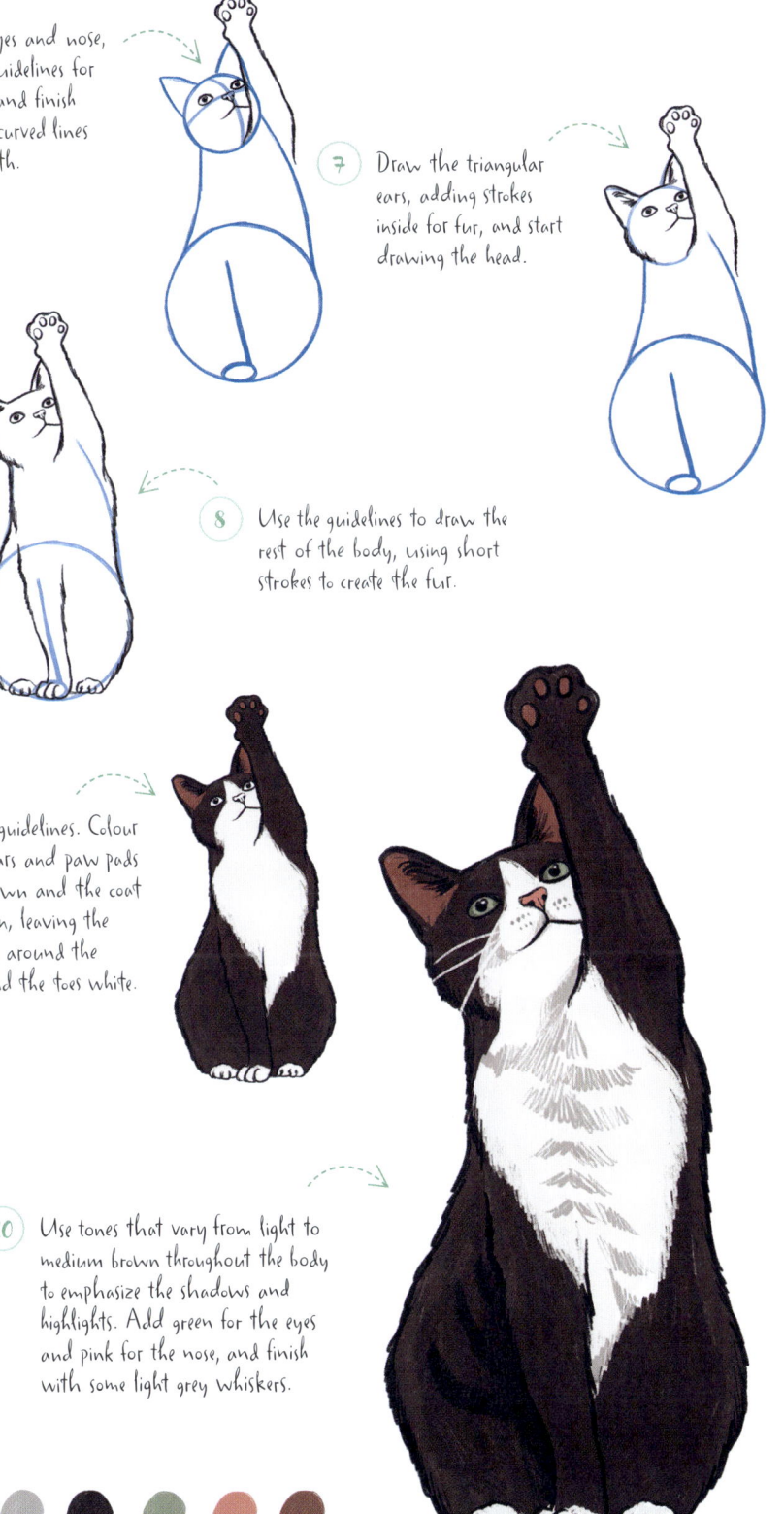

6 Trace the eyes and nose, using the guidelines for placement, and finish with two curved lines for the mouth.

7 Draw the triangular ears, adding strokes inside for fur, and start drawing the head.

8 Use the guidelines to draw the rest of the body, using short strokes to create the fur.

9 Erase your guidelines. Colour the nose, ears and paw pads reddish-brown and the coat dark brown, leaving the chest, neck, around the muzzle and the toes white.

10 Use tones that vary from light to medium brown throughout the body to emphasize the shadows and highlights. Add green for the eyes and pink for the nose, and finish with some light grey whiskers.

Reaching

This clever feline stands on its hind legs to reach up for a tasty treat. Cats also adopt this pose to make themselves look bigger to ward off predators.

1 Draw a circle guide, and add a triangular ear and a muzzle shape.

2 Draw a very long, bent U-shape for the body.

3 Add the guidelines for the legs. The left front leg will be straight up, the right front leg is bent and the hind legs have little bends, indicating the joints. Add circles for the paws and a curved line for the tail.

4 Sketch the eye as a small triangle at the top of the muzzle guide and add a small triangle for the nose at the tip. Add the ear.

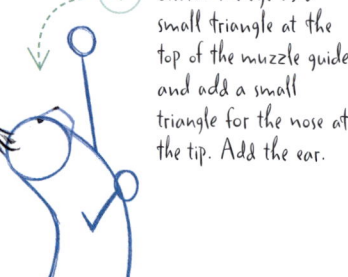

5 Add some curved lines for the mouth. Keep drawing the profile on the head, following the circle guide.

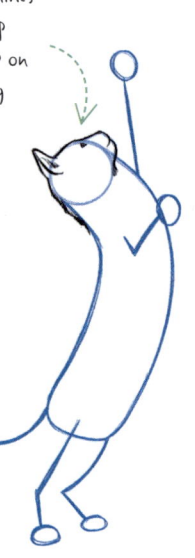

6 Use a series of short strokes along the front leg guidelines to create the fur. On the left leg, the toes are spread and we will be able to see under the paw.

7 Continue with the hind legs, adding short, curved lines for the paws.

8 Finalize your drawing by tracing the rest of the body and tail. Erase your guidelines.

9 Start with a light beige base colour for the coat, keeping the areas along the legs, belly and around the mouth lighter.

10 Add darker stripes all along the coat, with the same dark tone to the left paw and tip of the tail.

Stretching

Cats stretch to get their muscles moving after periods of inactivity. This content cat extends its forelegs and stretches out its neck as it awakens.

1 Draw two circle guides for the head and chest. Draw a horizontal line across the head.

2 Add a larger circle for the back, two triangular ears and a muzzle shape.

84

3 Draw four curved lines that connect the circles towards the back of the cat.

4 Trace two straight lines for the front legs and two bent lines for the hind legs. Add a long, curved tail.

5 Sketch a small line for the closed eye and the nose shape inside the muzzle. Trace the ears.

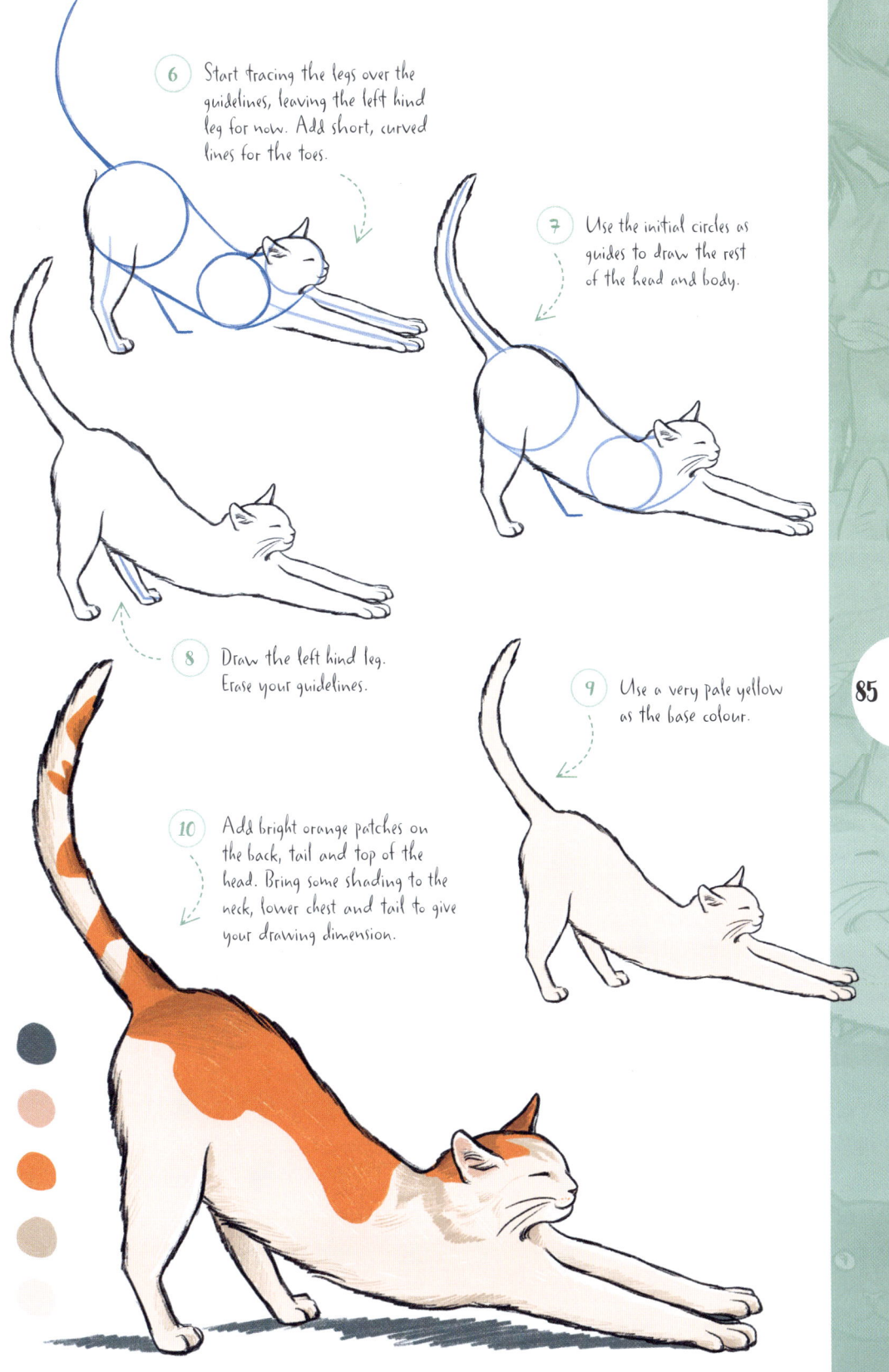

6 Start tracing the legs over the guidelines, leaving the left hind leg for now. Add short, curved lines for the toes.

7 Use the initial circles as guides to draw the rest of the head and body.

8 Draw the left hind leg. Erase your guidelines.

9 Use a very pale yellow as the base colour.

10 Add bright orange patches on the back, tail and top of the head. Bring some shading to the neck, lower chest and tail to give your drawing dimension.

Walking

When cats walk with their tails high in the air, they are expressing
confidence and contentment. Adapt these steps to suit any breed.

1 Draw two circle guides. Add a slightly curved, horizontal guideline on each, with a vertical guide across the centre of the first head and across the top-left section of the second head.

2 On the second head, add two triangular ears.

3 Draw two triangular ears on the first head. Add a muzzle shape on the second head and a square-like body.

86

4 Draw two vertical guidelines for the second cat's front legs. The first leg should bend at the middle to indicate the joint. Add a circular paw shape on the second leg. Trace a wavy tail line. Add a semicircular shape above the first head as a guide for its body.

5 Trace the first cat's front legs, adding a circular paw and a wavy tail.

6 Starting with the ears, trace around each head circle using quick, short strokes.

7 Draw the facial features, using the guidelines for placement. Add a thin oval in the middle of each eye for the pupils. Trace the front leg shapes over the guidelines.

8 Finish tracing the rest of the cats' bodies. Add a few lines for the second cat's hind legs (the first cat's hind legs are hidden). Erase your guidelines.

9 Colour the first cat's body light grey and use a sandy base colour for the second.

10 Add shading, using dark grey for the first cat and medium brown for the second. Colour their noses pink and their eyes light blue or green.

Running

The average house cat, with no training, conditioning or stretching,
can bolt at an amazing speed of about 38kph (30mph),
quicker than the world's fastest human runner.

1 Draw a circle guide. Add a muzzle shape and a triangular ear.

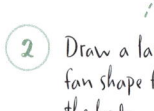

2 Draw a large fan shape for the body.

3 Draw a curve in the middle of the body. Erase the two lines below the curve. Add another curved line for the tail.

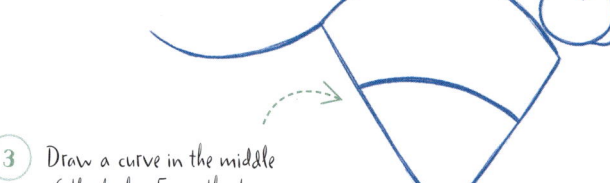

4 Under the body shape, draw two lines for the hind legs, bent in the middle towards the right side.

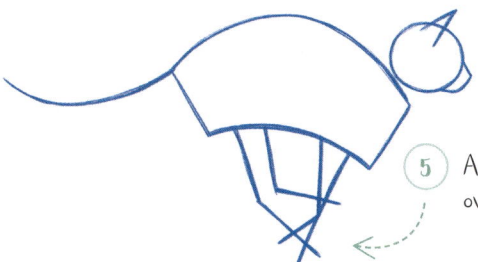

5 Add the front leg guidelines, overlapping the hind legs.

88

6 Start tracing the ear and the nose within the muzzle guidelines. Finally, add a circle for the eye, level with the top of the muzzle.

7 Use the guidelines to draw the right hind leg. Trace the head from the ear towards the neck.

8 Keep drawing the rest of the body with short strokes. Draw around the guidelines for the front right leg (part of it is hidden behind the leg you've just drawn).

9 Trace the left legs, without overlapping the previously drawn legs. Draw around the tail guideline, using slightly longer strokes to make it furry. Finish by drawing around the back and neck area. Erase your guidelines.

10 Use a light brown base tone, and add darker brown markings all over the body, legs, face and tail.

Jumping

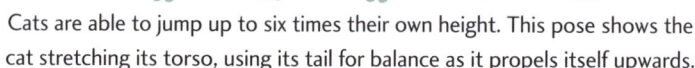

Cats are able to jump up to six times their own height. This pose shows the cat stretching its torso, using its tail for balance as it propels itself upwards.

1 Draw a circle guide. Add a muzzle shape and triangular ears, one tucked behind the other.

2 Draw a larger circle for the chest.

90

3 Add another circle on the lower left side, slightly bigger than the head circle. Use the green dotted guidelines to help you with placement. The further away it is from the other two circles, the longer your cat will be.

4 Draw the front leg guideline. Starting within the chest circle, draw a straight line to the circle edge that bends and continues, slightly curved, out of the circle.

5 Add the hind leg – a long, curved line that follows the green dotted guideline.

6 Link the three circles together with curved lines for the neck, back and belly. Make these lines wider for a fluffier cat, or stick closer to the body structure for a skinny outline. Add a curved tail.

7 Add the facial features and draw the head. Draw the front leg, making it wider at the top. Add some extra strokes for the fur on the elbow. Finish with short, curved lines for the toes.

8 Move on to the back leg. This is more furry and even wider at the top where the thigh is. Create the toes with a few curved strokes.

9 Keep tracing the body.

10 Add the legs on the other side (we only see part of them). Erase your guidelines and polish your drawing with small strokes here and there. Add colour, according to the breed.

Bombay

This standing pose shows off the Bombay's stocky, muscular profile. The head, tip of the ears, eyes, chin and feet are all typically round.

1 Draw three circle guides for the body. The overlapping circle on the top right will become the head.

2 Draw two straight, intersecting lines on the head and two triangular ears.

3 Draw two curved lines that connect the body circles. Trace the guidelines for the right legs, both bent in the same direction, and add oval paws.

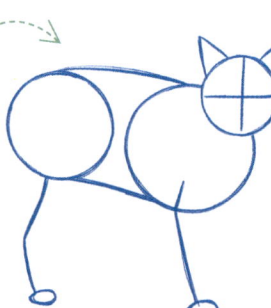

4 Under the first circle, draw a guideline that bends the same way as the right hind leg. Under the chest circle, draw a guideline bending towards the left. Add a long, curved tail.

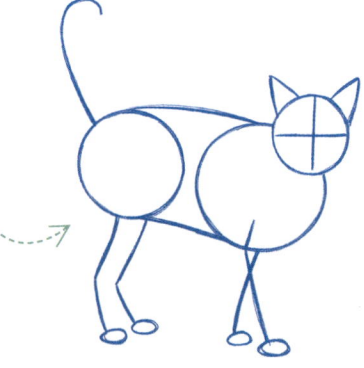

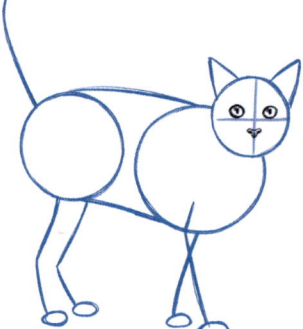

5 Lightly sketch the eyes and nose, using the guidelines for placement.

92

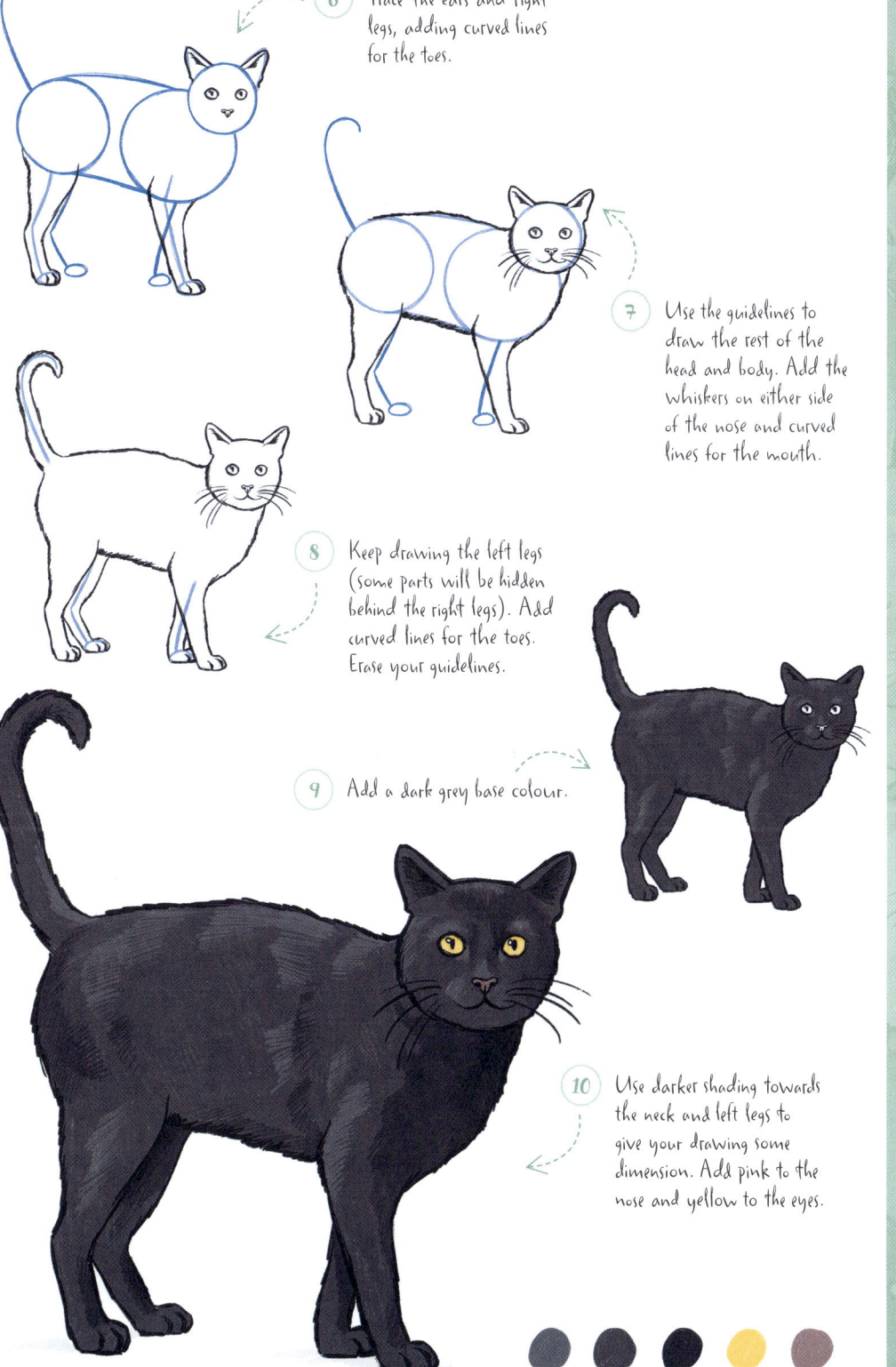

6 Trace the ears and right legs, adding curved lines for the toes.

7 Use the guidelines to draw the rest of the head and body. Add the whiskers on either side of the nose and curved lines for the mouth.

8 Keep drawing the left legs (some parts will be hidden behind the right legs). Add curved lines for the toes. Erase your guidelines.

9 Add a dark grey base colour.

10 Use darker shading towards the neck and left legs to give your drawing some dimension. Add pink to the nose and yellow to the eyes.

Siamese

Siamese cats have beautiful blue eyes, sleek bodies and fine, glossy coats.
This pair, with their interlocking tails, look like the best of friends.

1) Draw two oval guides.
Add two triangular ears.

2) Add intersecting guidelines
across the heads.

3) Draw circle shapes
for the chests.

4) Draw two vertical lines for the front
legs, bending the second at the middle
to indicate the joints. Add circular
paws. Trace a curved line, joining the
middle of the head, below the ear, to
the bottom left of the body.

5) For the first cat, trace a diagonal
guideline, with a circle at the end for
the right hind leg. Add two curled,
intertwining lines for the tails.

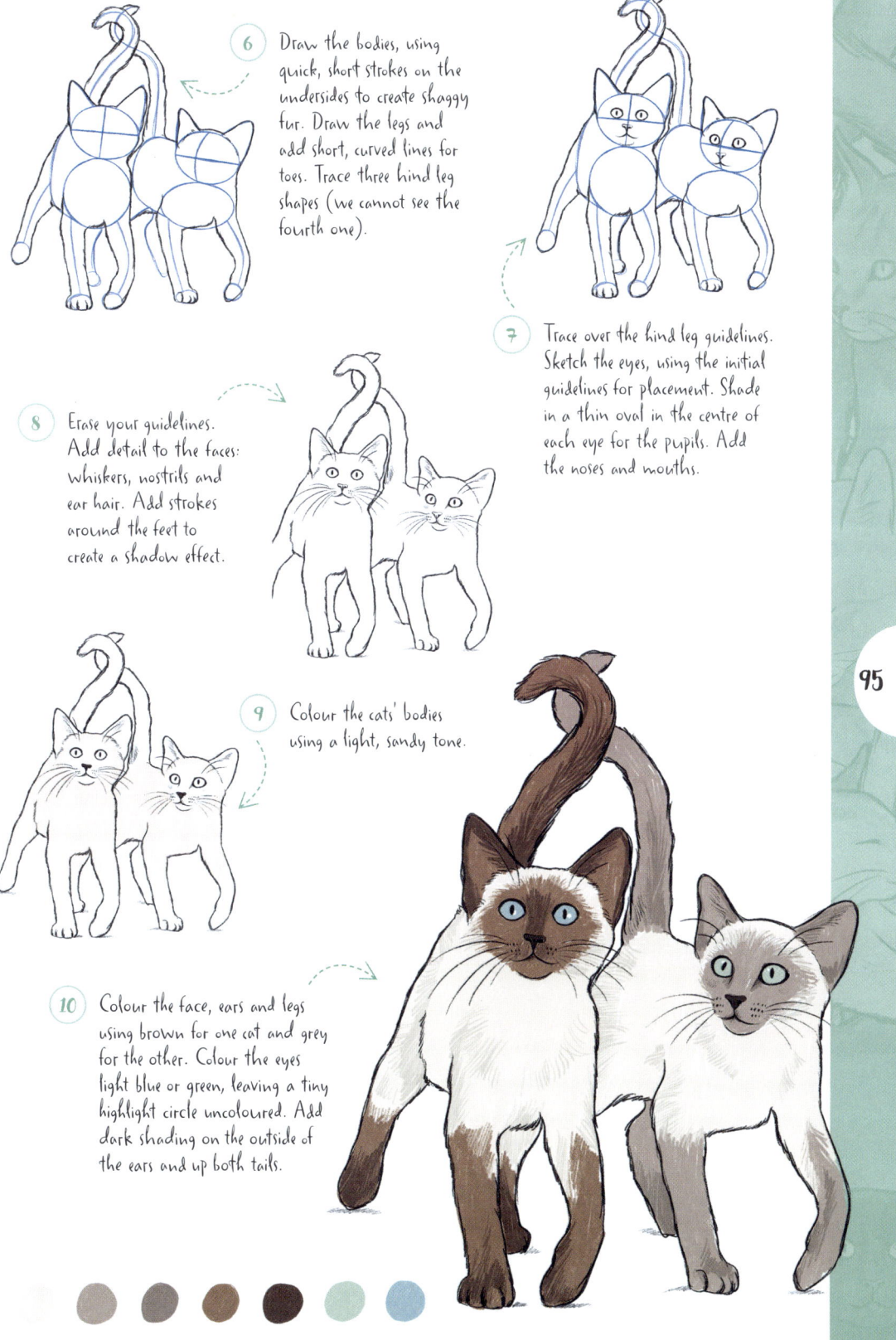

6 Draw the bodies, using quick, short strokes on the undersides to create shaggy fur. Draw the legs and add short, curved lines for toes. Trace three hind leg shapes (we cannot see the fourth one).

7 Trace over the hind leg guidelines. Sketch the eyes, using the initial guidelines for placement. Shade in a thin oval in the centre of each eye for the pupils. Add the noses and mouths.

8 Erase your guidelines. Add detail to the faces: whiskers, nostrils and ear hair. Add strokes around the feet to create a shadow effect.

9 Colour the cats' bodies using a light, sandy tone.

10 Colour the face, ears and legs using brown for one cat and grey for the other. Colour the eyes light blue or green, leaving a tiny highlight circle uncoloured. Add dark shading on the outside of the ears and up both tails.

Norwegian Forest

An elegant breed with a semi-longhair coat, long legs and a bushy tail, the Norwegian Forest is larger than the average cat, with a loving personality.

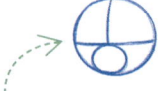

1 Draw an oval guide. Add a horizontal line across and a curved, vertical line through the top half. Draw a circle for the muzzle guide.

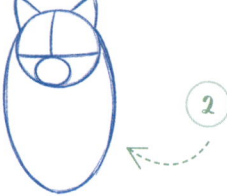

2 Draw two triangular ears. Add a large U-shape for the chest.

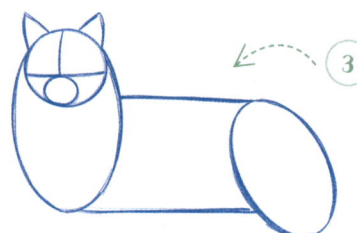

3 Add two horizontal lines going to the right side, and draw a tilted oval shape at their end, slightly smaller than the chest shape.

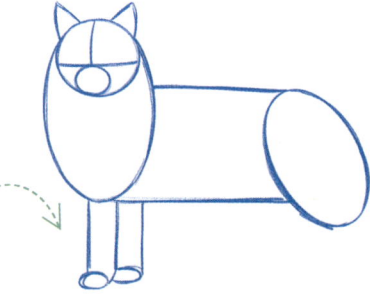

4 Add guidelines for the front legs under the chest, with ovals for paws.

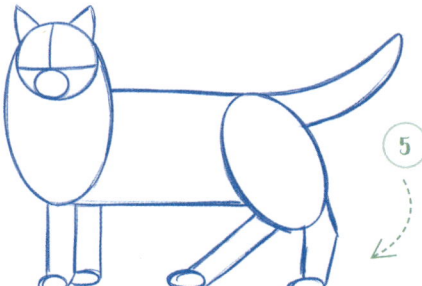

5 Add the hind legs under the second oval. Draw a tail shape.

6 Sketch two circles for the eyes, using the guides for placement. Draw dark lines for the pupils. Within the muzzle guide sketch the nose. Add nostrils, two curved lines for the mouth and a smaller curve for the chin.

7 Use guidelines to draw the front and hind legs, using short strokes to create the fur.

8 Continue to draw the body with short strokes for the fur and longer strokes for the tail, chest and belly. Erase your guidelines.

9 Add a light brown base colour, leaving a white blaze on the chest.

10 Add some darker stripes and markings to emphasize the shadows and highlights. Colour the eyes green.

Burmilla

Burmillas have short, soft coats, so keep your strokes short when drawing to avoid a furry texture. While they are placid, they also love their daily playtime.

1 Draw three circle guides for the head and body. The centre and left circles should touch, leaving a short gap between the smaller head on the right.

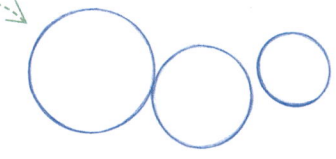

2 Draw a small muzzle shape and two triangular ears.

3 Draw three curved lines to connect the circles for the neck and back.

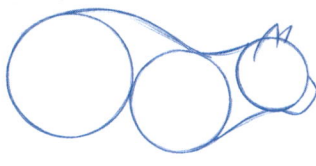

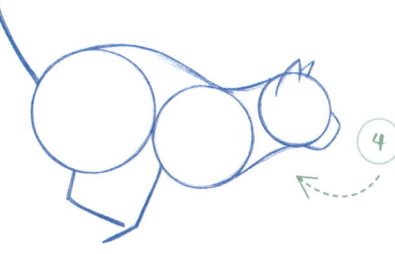

4 Under the left-hand circle, draw a guideline for the hind leg that bends near the top for the joint. Under the middle circle, add a front leg guide, bent towards the left. Add a long, curved tail.

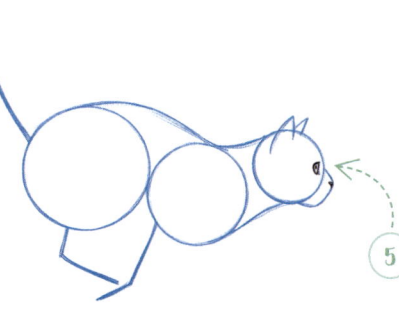

5 Sketch the eye and add a small triangle for the nose at the tip of the muzzle.

6 Trace the ears and draw the rest of the head, making the top a little thinner. Curve the lines to the left of the eye to emphasize the cranial structure.

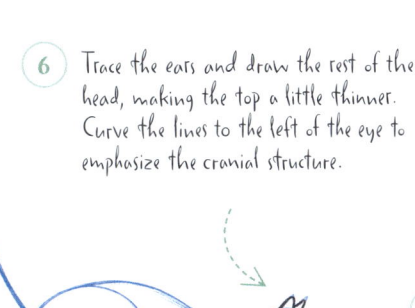

7 Draw the right legs, making them thicker at the top and curving the shapes where the guide bends to create the joints and feet. Add curved lines for the toes.

8 Draw the rest of the body with short strokes. Trace the guidelines for the left legs (parts will be hidden behind the legs you've just drawn).

9 Draw the left legs without overlapping the previously drawn legs. Add the tail, using slightly longer strokes to make it furry. Erase your guidelines.

10 Draw the whiskers. Use a base colour with light yellow or beige tones. Add thin stripes along the back, the neck and on the tail using a darker value.

Chausie

Chausies are long-legged, statuesque cats, built for running and jumping.
Cats have an inherent 'righting reflex', which enables them to land on their feet.

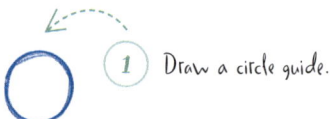

1 Draw a circle guide.

2 Add two triangular ears pointing forwards and the muzzle at the bottom of the head shape.

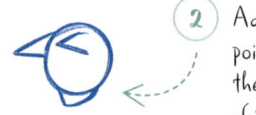

3 Draw a curved line for the back, three times the length of the head. Add a short line below the muzzle.

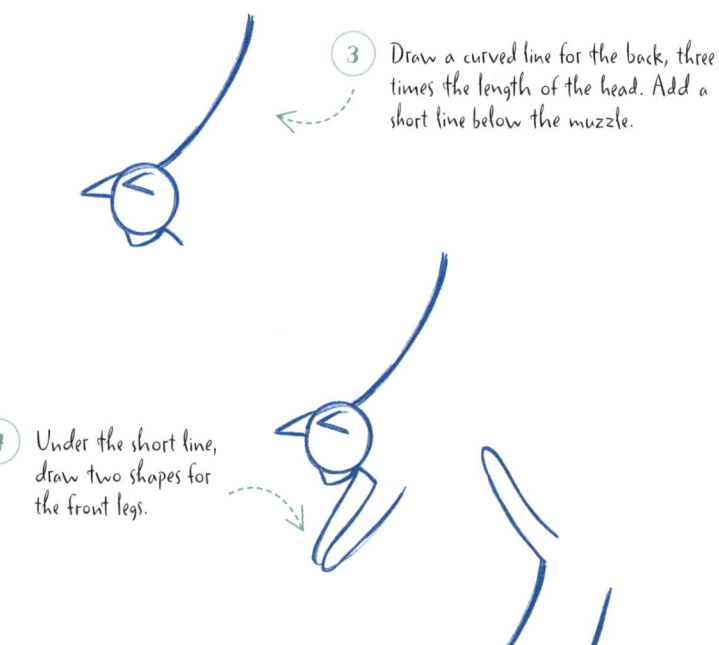

4 Under the short line, draw two shapes for the front legs.

5 Trace a parallel line along the belly. Add the tail shape.

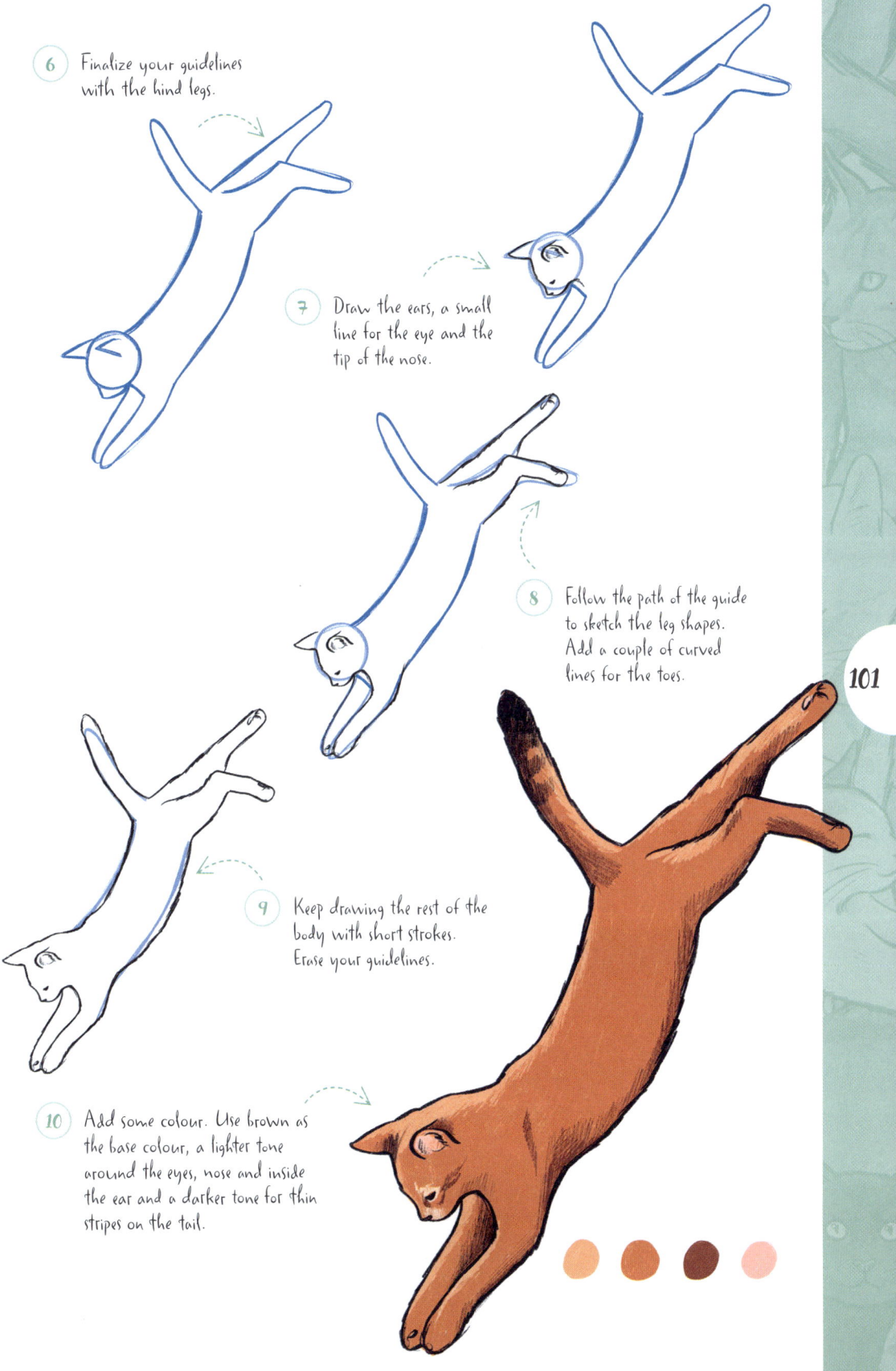

6 Finalize your guidelines with the hind legs.

7 Draw the ears, a small line for the eye and the tip of the nose.

8 Follow the path of the guide to sketch the leg shapes. Add a couple of curved lines for the toes.

9 Keep drawing the rest of the body with short strokes. Erase your guidelines.

10 Add some colour. Use brown as the base colour, a lighter tone around the eyes, nose and inside the ear and a darker tone for thin stripes on the tail.

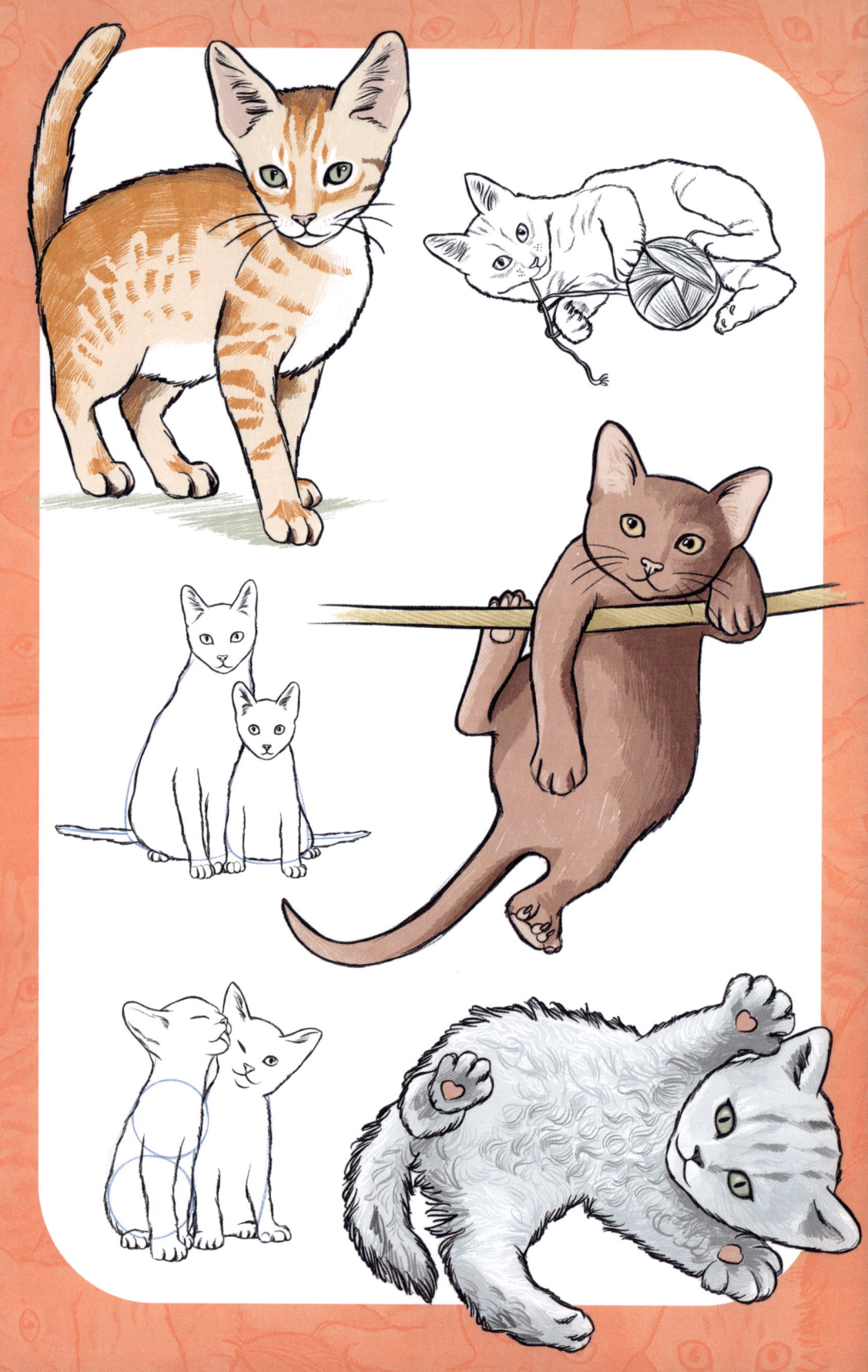

Cats & kittens

Licking paw

At a very young age, kittens learn to lick themselves clean by watching their mothers groom themselves and copying their actions.

(1) Draw a circle guide. Add a straight, vertical guideline, with a horizontal line across the bottom section.

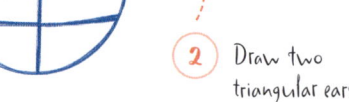

(2) Draw two triangular ears.

(3) Add a tiny semicircle for the tongue.

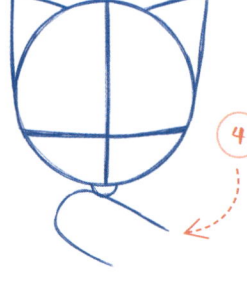

(4) Add a curved shape for the paw.

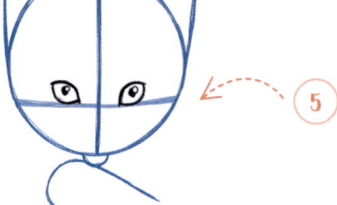

(5) Sketch two large, oval eyes, making them pointier on the insides.

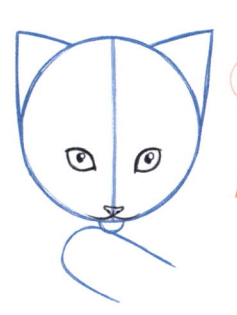

6 Along the vertical line, towards the bottom of the circle, sketch the nose. Add two curved lines for the mouth.

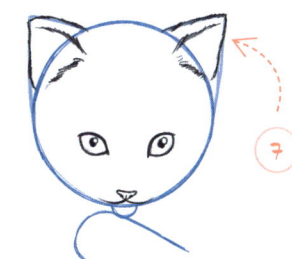

7 Trace the ears, adding detail lines inside.

8 Follow the head outline, using short strokes to show the fur. Continue with the paw. Erase your guidelines.

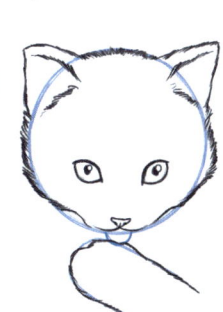

9 Colour the head in light brown, with highlights around the eyes, ears, mouth and on the side of the head. Colour the nose brown, the tongue in pink and the eyes in light blue, leaving a tiny highlight circle uncoloured.

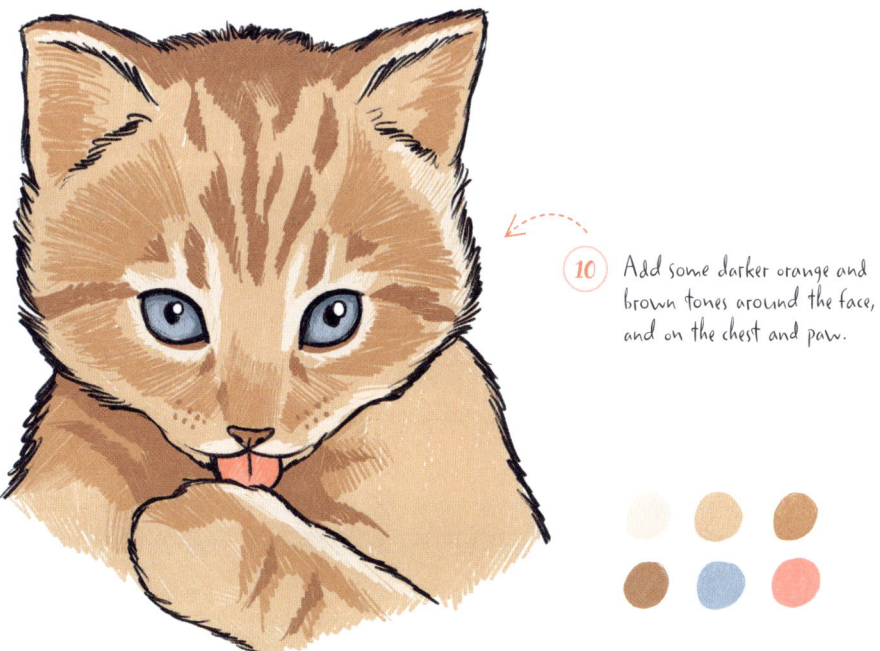

10 Add some darker orange and brown tones around the face, and on the chest and paw.

Balancing

From impressive jumps to unbelievable balance, cats are one of the most agile animals.
Their playfulness and acrobatic ways make for endless hours of entertainment.

1 Draw a circle guide. Add two slanted, intersecting guidelines.

2 Add two triangular ears. Trace two lines under the head for the rope.

3 Draw a long, curved shape across the rope guidelines for the front leg. Add another small oval on the right side of the head for the other front paw.

4 Add another long oval on the left side for the hind paw, and trace a larger U-shape underneath for the body.

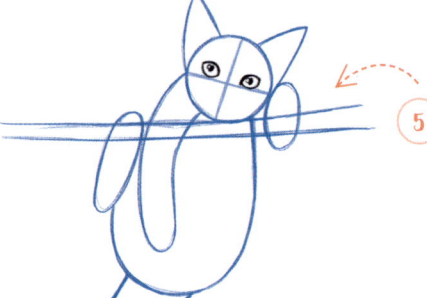

5 Add a curved line for the tail, hanging down to the left. Trace two large eyes along the horizontal guideline.

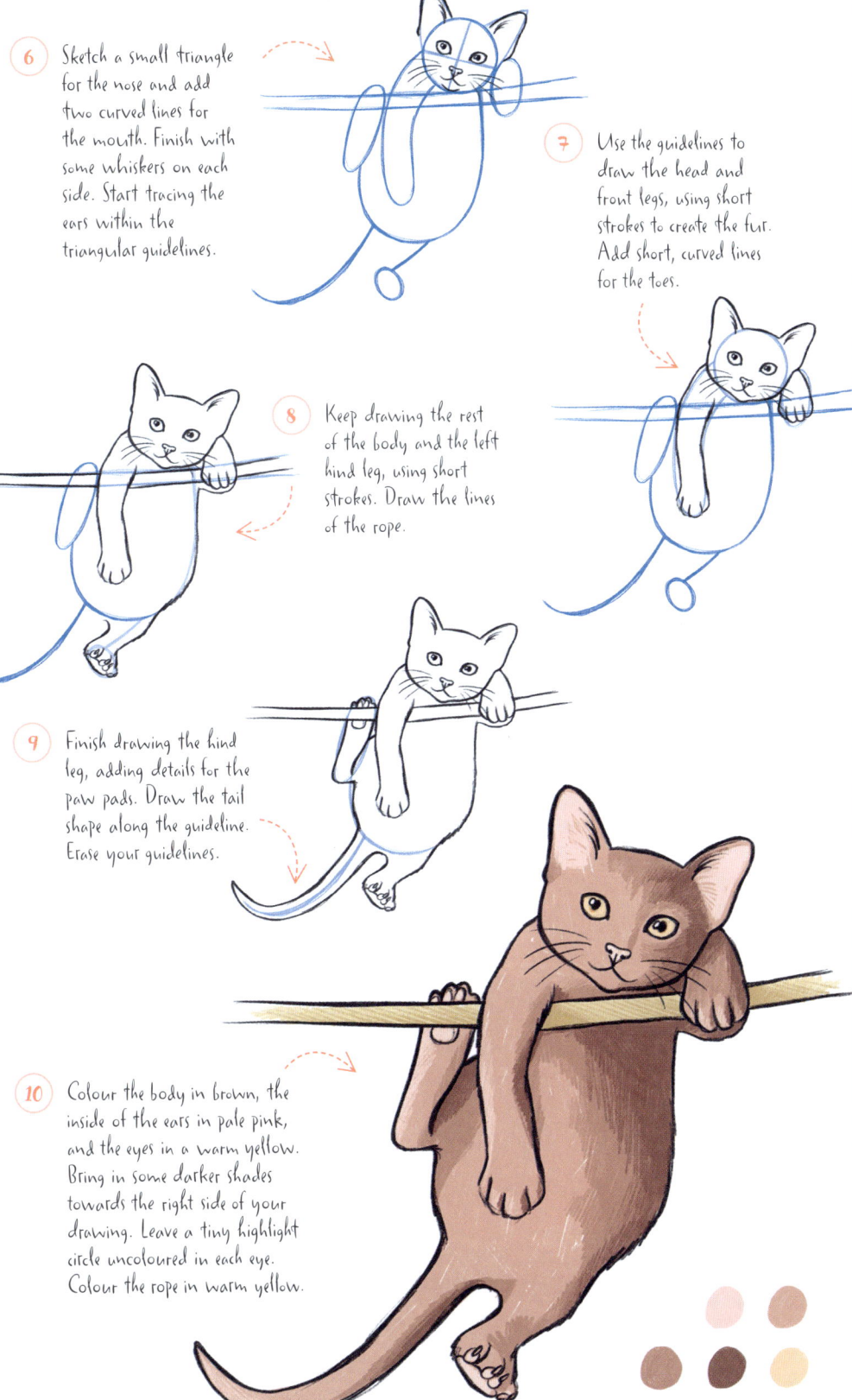

6 Sketch a small triangle for the nose and add two curved lines for the mouth. Finish with some whiskers on each side. Start tracing the ears within the triangular guidelines.

7 Use the guidelines to draw the head and front legs, using short strokes to create the fur. Add short, curved lines for the toes.

8 Keep drawing the rest of the body and the left hind leg, using short strokes. Draw the lines of the rope.

9 Finish drawing the hind leg, adding details for the paw pads. Draw the tail shape along the guideline. Erase your guidelines.

10 Colour the body in brown, the inside of the ears in pale pink, and the eyes in a warm yellow. Bring in some darker shades towards the right side of your drawing. Leave a tiny highlight circle uncoloured in each eye. Colour the rope in warm yellow.

Playing with wool

Match the eye colour of the kitten to the ball of yarn for a cute final touch.
To make the kitten tortoiseshell, add some darker patches, too.

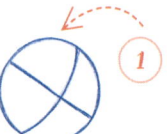

1 Draw a circle guide with two intersecting guidelines.

2 Draw two triangular ears and a small, oval muzzle guide.

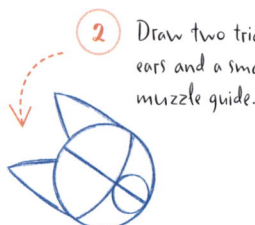

3 Trace the body shape. As the green dotted line shows, the top of the body is at the same height as the tip of the left ear. Draw a circle for the yarn ball around the middle of the bottom line.

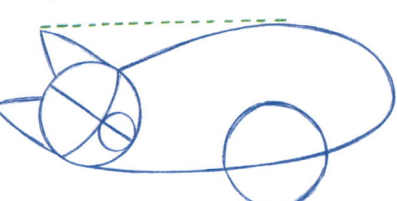

4 Add two oval paws touching the top of the ball: one on the lower right side, and another a little further to the left, below the body line.

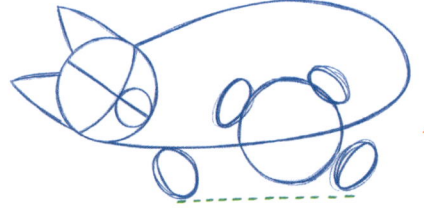

5 Sketch the bent leg shapes from the body to the paw circles. Sketch two almond-shaped eyes, making them pointier at the corners. Add the nose and two curved lines for the mouth.

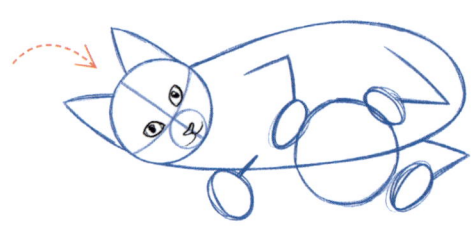

6 Use the guidelines to draw the ears, paws and legs, adding short lines for the toes.

7 Keep drawing the rest of the body with short strokes. Draw the details of the wool string.

8 Erase your guidelines and add small strokes to create a fur effect. Add some long lines on the yarn ball.

9 Colour the kitten in pale yellow and orange shades, adding lighter strokes on the face, front of the body and legs.

10 Colour the eyes and the yarn ball in blue-green, leaving a tiny highlight circle uncoloured in each eye. Add thin stripes along the body using a darker orange shade.

Arching

When they feel threatened, cats arch their back, turn sideways and raise their fur. This presents a larger, more impressive profile to scare away rivals.

1 Draw a circle guide. Add a horizontal line towards the bottom of the circle and a curved, vertical line down the top left. Draw a muzzle shape.

2 Add two triangular ears. Start tracing the first front leg, with two long curves going down towards an oval paw shape.

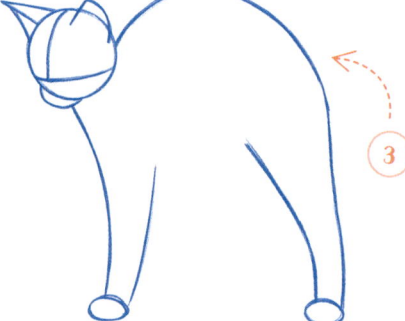

3 Draw a long, curved line for the back that connects to the hind leg. Add another parallel line for that leg, and an oval for the paw.

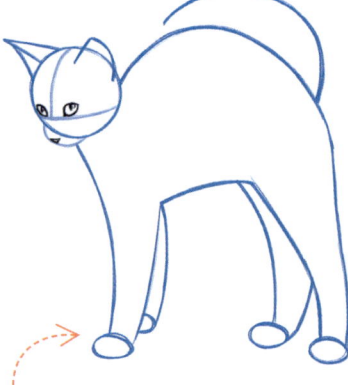

4 Add the left legs, which are partially hidden by the right legs. Add another line for the belly and a long curve for the tail.

5 Draw two ovals for the eyes, using the guidelines for placement and shading in vertical ovals for pupils. Inside the muzzle, sketch the nose.

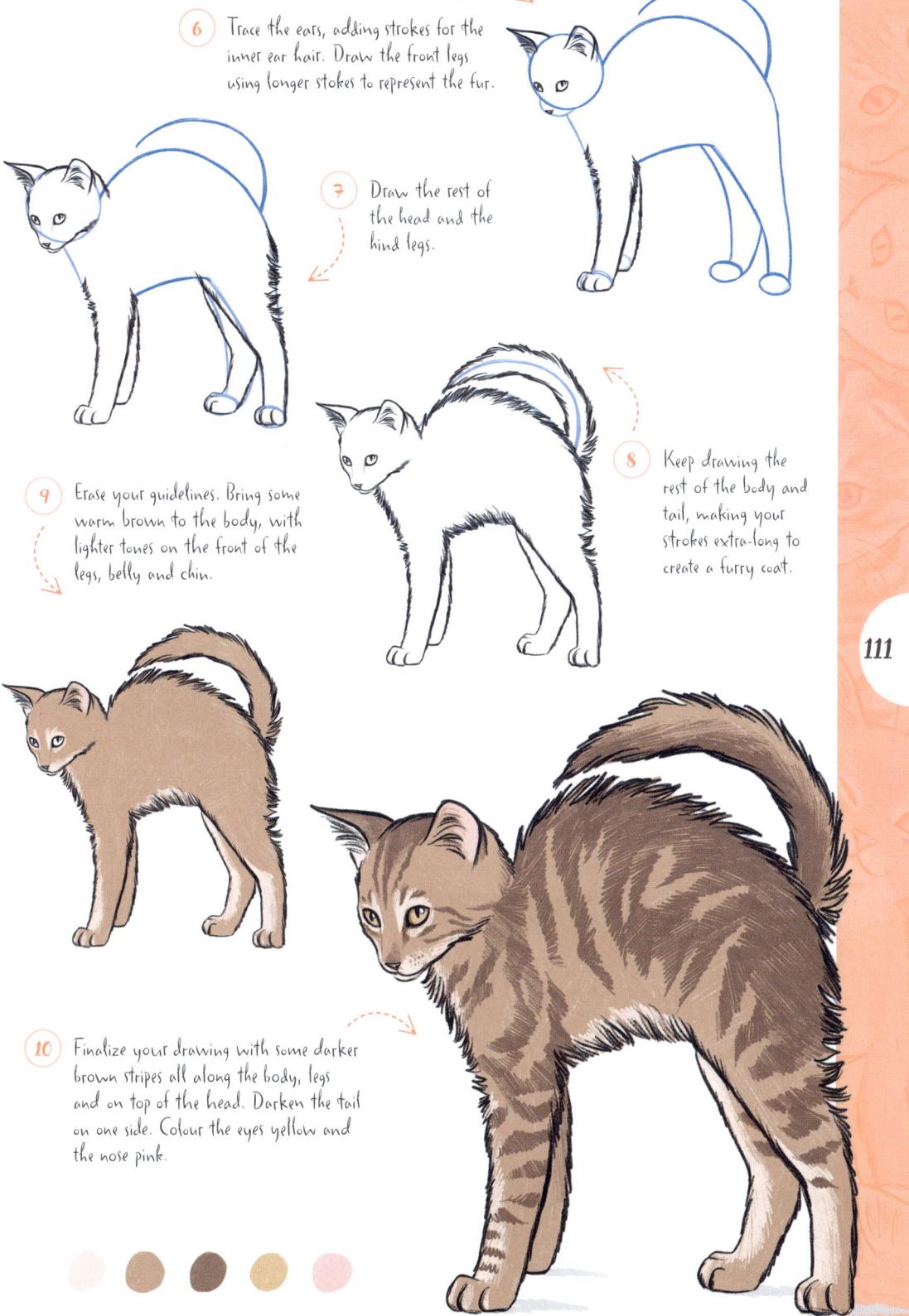

6 Trace the ears, adding strokes for the inner ear hair. Draw the front legs using longer stokes to represent the fur.

7 Draw the rest of the head and the hind legs.

8 Keep drawing the rest of the body and tail, making your strokes extra-long to create a furry coat.

9 Erase your guidelines. Bring some warm brown to the body, with lighter tones on the front of the legs, belly and chin.

10 Finalize your drawing with some darker brown stripes all along the body, legs and on top of the head. Darken the tail on one side. Colour the eyes yellow and the nose pink.

Mother & kitten

This beautiful mother cat sits proudly beside her kitten. You can have fun experimenting with colours, patterns and guideline shapes to draw different breeds.

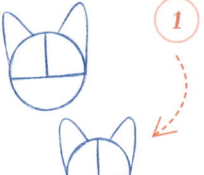

1 Draw two circle guides – the smallest on the lower right. Add a horizontal line across each circle, with a vertical line splitting the top half. Add the triangular ears.

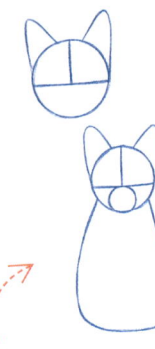

2 Draw the kitten's U-shaped body and a circular muzzle guide.

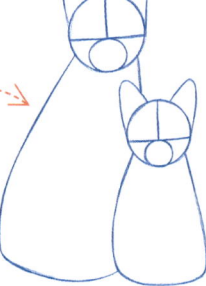

3 Repeat for the mother (part of her body is hidden behind the kitten's).

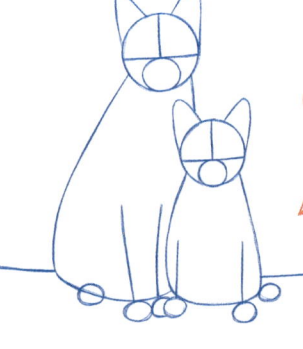

4 Draw straight guidelines with circular paws for the front legs and another circular hind paw popping out from under the body on each cat. Add a straight tail line.

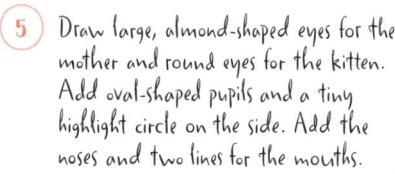

5 Draw large, almond-shaped eyes for the mother and round eyes for the kitten. Add oval-shaped pupils and a tiny highlight circle on the side. Add the noses and two lines for the mouths.

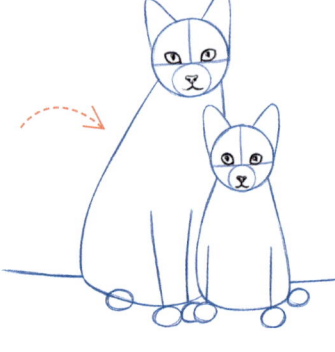

6 Draw the ears, adding quick, short strokes for the fur inside. Sketch the kitten's front legs, using short strokes and adding curved lines for the toes.

7 Draw the heads, tracing the mother's cheeks within the guidelines for a more triangular shape. Trace her front legs around the guidelines.

8 Draw the rest of the cats' bodies and tails, using quick, short strokes. Erase your guidelines.

9 Add a sandy base colour for the mother and a lighter shade for the kitten, keeping its chest white.

10 Add stripes and shading, using different tones to emphasize the shadows and highlights. Colour the eyes light yellow and the noses pink.

Abyssinians

Abyssinians have round, wedge-shaped heads, almond-shaped eyes, large ears and close-lying coats. These adorable kittens groom each other to strengthen their social bonds.

1 Draw three circles, with the lower two touching and the head slightly apart.

2 Add a triangular ear and a rectangular muzzle shape. Add a circle guide for the second kitten's head, touching the muzzle. Add straight, intersecting guidelines, tilted towards the right.

3 Add two triangular ears and a circular muzzle guide. Connect the three circles on the first kitten with curved lines, to create the neck and body.

114

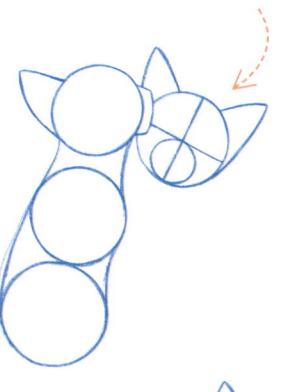

4 For the first kitten, draw two vertical guidelines for the front legs (the left leg is slightly hidden behind the right). Add oval paws at the end of each line and a third paw under the bottom circle. For the second kitten, trace a vertical body shape. Add two lines for the front legs and three ovals for paws.

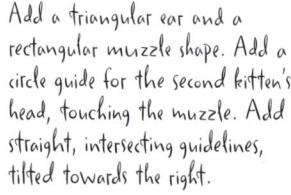

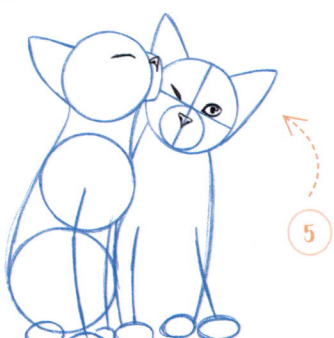

5 Draw the eyes and noses. The second kitten has a slanted, closed eye and a wider, oval eye, with an oval pupil and a tiny highlight circle beside it. Draw a line for the first kitten's closed eye.

6 Trace the ears, using quick, short strokes to create fur inside.

7 Trace around the front leg guidelines, using short strokes. Add curved lines for the toes.

8 Finish drawing the bodies with the same short stroke effect. Erase your guidelines.

9 Colour around the eyes, noses and necks in light yellow. Use an orange tone for the rest of their coats. Shade the eye light blue, leaving the tiny highlight circle uncoloured. Colour the nose and tongue light pink and add white whiskers.

10 Add shading to your drawing with a darker, sandy colour.

Exotic Shorthair

Exotic Shorthairs have broad heads, small, wide-set ears, large round eyes, short legs and bushy tails. This blue-eyed kitten is demonstrating its laid-back personality.

1 Draw a circle guide for the head.

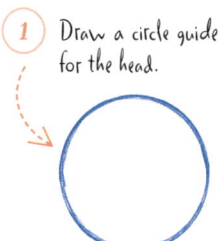

2 Add two triangular ears. Draw a horizontal line going across the circle, and a small, vertical line through the bottom section, tilting these guidelines to the left.

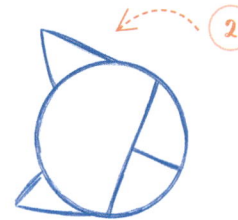

3 Trace a similar-sized circular shape on the left side for the body.

4 Draw the guidelines for the legs, making the left legs shorter than the right ones due to the lying-down perspective. Add circles at the tip of each line for the paws.

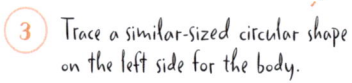

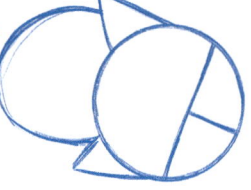

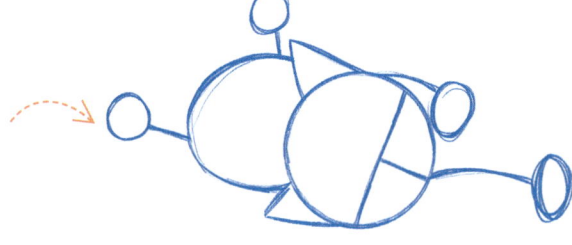

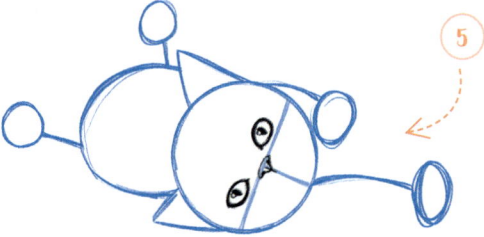

5 Sketch two large, oval eyes, using the guidelines for placement and making the inner sides pointier at the corners. Sketch the nose where the guidelines meet.

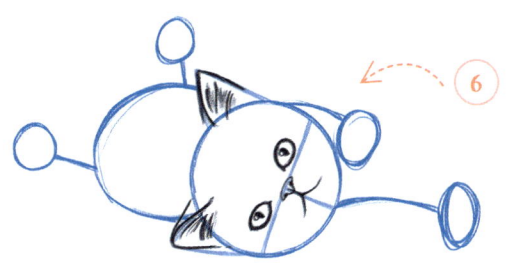

6 Finalize the muzzle with two curved lines for the mouth. Use the guidelines to draw the ears, adding short strokes for the fur inside.

7 Keep drawing the rest of the head and body with short strokes. Add whiskers at either side of the nose.

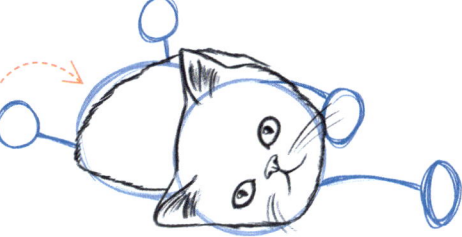

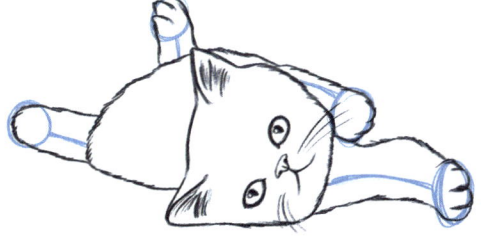

8 Trace the legs around the guidelines, adding short lines on the paws to create the toes.

9 Erase your guidelines, and add some shading to your drawing.

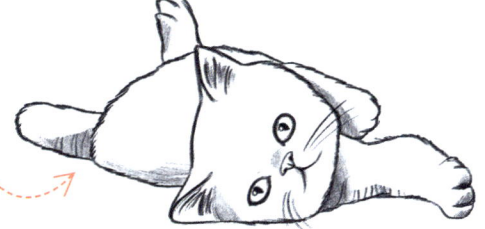

10 Start with a light beige base colour. Using a darker brown tone, add thin stripes on the forehead, legs and tail. Use a light blue colour for the eyes.

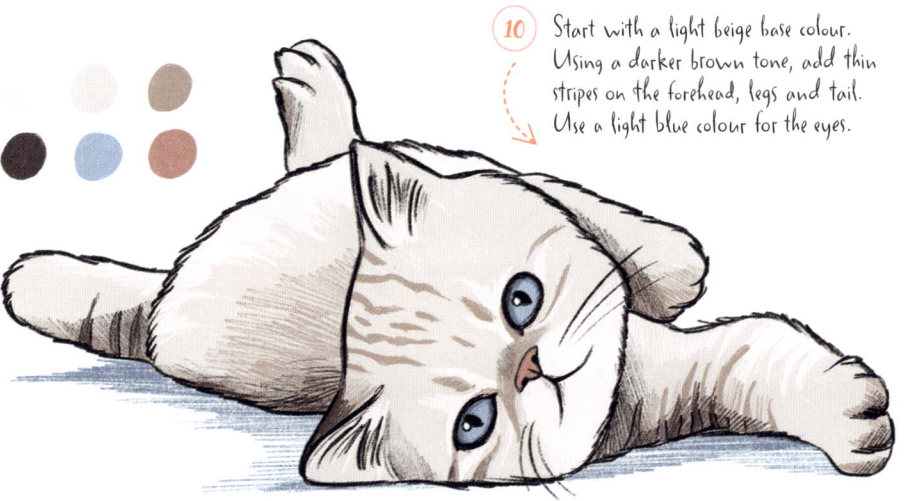

LaPerm

The LaPerm's most stand-out feature is its bouncy, curly coat.
This clever kitten has a sense of humour and loves getting into mischief.

1 Draw a circle guide for the head.

2 Add two triangular ears. Draw a vertical line across the left side of the circle, and a horizontal line through the right-hand section for the large forehead. Add a circular muzzle on the left side.

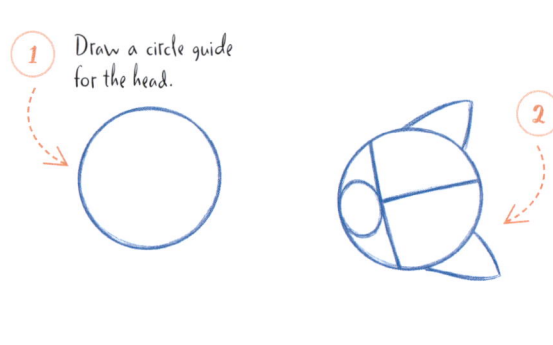

3 Add two circular shapes for the front paws on each side of the head. Trace two parallel, curved lines for the body, connecting to the paws.

4 Finish the guidelines for the bottom of the body. Trace a circle and a U-shape for the right hind leg. (The left hind leg will be on its side.)

5 Add the tail shape. Sketch two almond-shaped eyes, using the guidelines for placement and making the inner sides pointier at the corners.

6 Sketch the nose, with two curved lines for the mouth. Draw the ears, adding detail inside.

7 Use the guidelines to draw the rest of the head and front legs, using short strokes to create the fur. Add detail on the paws.

8 Draw the hind legs with short strokes, adding pad detail to the upper hind paw and curved lines for toes on the lower paw.

9 Finish tracing the body and tail with long strokes for extra fluff factor. Erase your guidelines. Colour the body in light grey tones.

10 To add the curly effect, make your lines very short and curvy when shading. Colour the paw pads in pink and the eyes in light green, leaving a tiny highlight circle uncoloured.

American Shorthair

The American Shorthair is a powerful breed, with a broad chest, muscular neck, strong jaw and chunky legs. Its tabby coat is thick and dense.

(1) Draw a circle guide.

(2) Add two triangular ears. Draw a horizontal guideline crossing the bottom half of the circle, with a vertical line splitting the top half for the large forehead. Add an oval muzzle shape in the lower section.

(3) Trace a rectangular body shape.

(4) Trace the front leg shapes with semicircular paws, and add a curved shape at the top-right corner of the rectangle for the tail.

(5) Add the final guideline for the hind legs and paws.

6. Using the guidelines for placement, sketch the almond-shaped eyes, with oval pupils and a tiny highlight circle beside them. Inside the muzzle, draw the nose and two curved lines for the mouth.

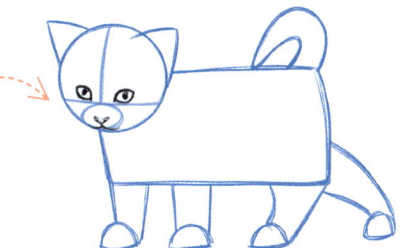

7. Follow the guidelines to draw the ears, using short strokes on the insides to create fur. Sketch the front legs. Add short lines on the paws for the claws.

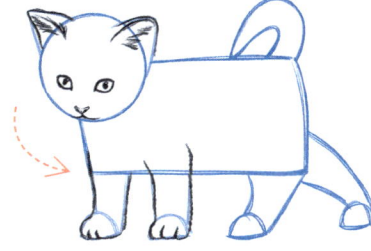

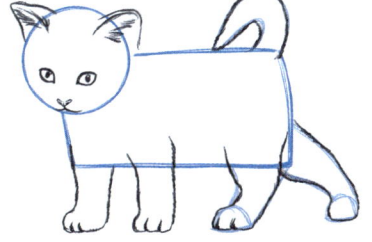

8. Keep drawing the hind legs and tail with short strokes.

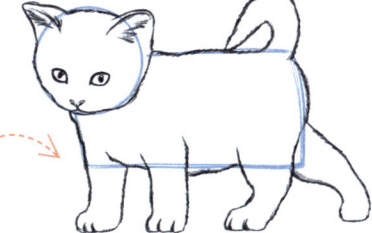

9. Finish tracing the body with short strokes, using the rectangular shape only as a rough guideline and adding curves to make your kitten more realistic. Erase your guidelines.

10. Colour the body in light grey tones. Add some dark grey strokes on the forehead and body to create a tabby coat. Colour the ears pink and the eyes light blue, leaving the tiny highlight circles uncoloured.

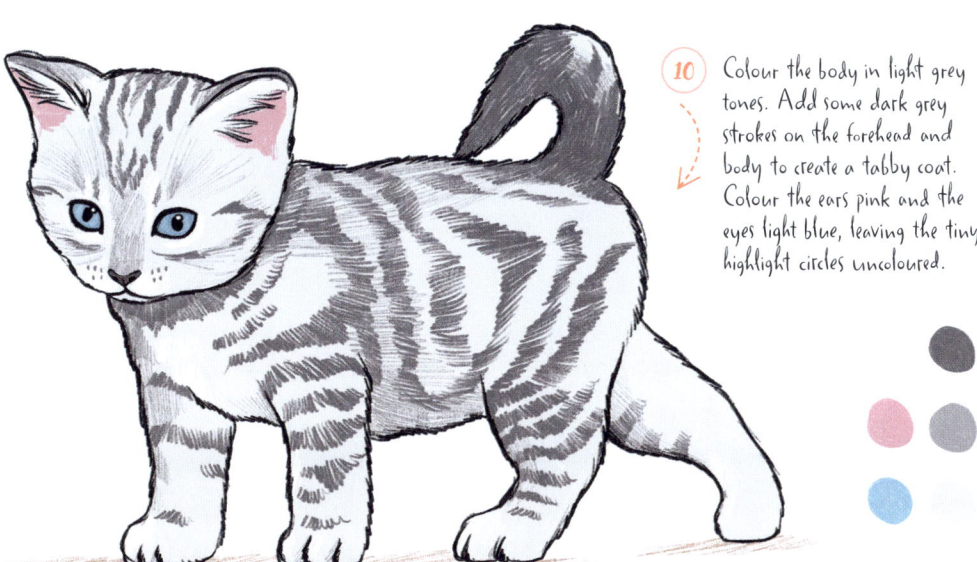

Scottish Fold

Distinguishable by their folded ears, Scottish Folds are loving, social and smart. They come in a variety of colours and patterns, including solid, tabby and bicolour.

1 Draw a circle guide.

2 Draw a horizontal guideline across the bottom half of the circle, with a vertical line splitting the top half for the large forehead. Add a rectangular muzzle shape.

3 Draw two triangular ears, making sure they overlap the circle guideline. Add a U-shape for the body, about twice the size of the head.

4 Add four lines for the front legs, with circular shapes at the tips for the paws.

5 Sketch two circular eyes, using the guidelines for placement. Add circular pupils, with tiny highlights inside. Within the muzzle, lightly sketch the nose, with two short, curved lines for the tiny mouth.

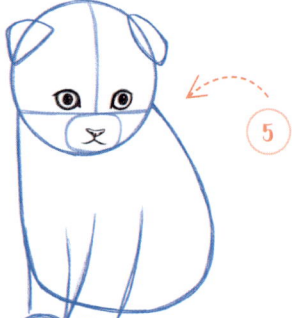

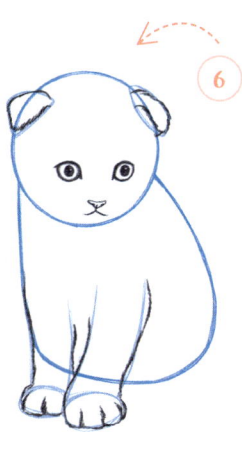

6 Use the guidelines to draw the ears and front legs, using very short strokes to create the fur. Add curved lines for the toes.

7 Continue using very short strokes to draw the outline of the head.

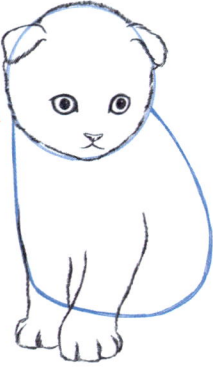

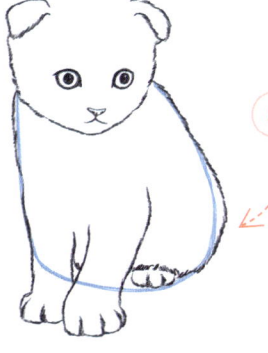

8 Finish tracing over the guidelines for the rest of the body. You can add a back paw popping out from under the kitten's fur, with curved lines for claws. Erase your guidelines.

9 Add some shading. Trace a few whiskers on each side of the nose. Start with a sandy base colour for the coat, and add some light brown shading.

10 Use light and medium brown tones to emphasize shadows and highlights. Colour the eyes light blue, leaving the tiny highlight circles uncoloured.

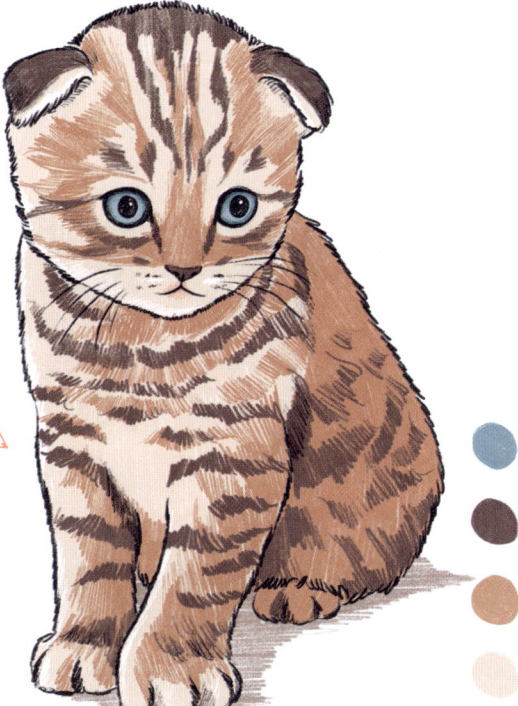

Tonkinese

The Tonkinese breed comes in a range of colours. Their coats are short and close-lying, with a fine, soft and silky texture.

1 Draw two circle guides. On each circle, add a horizontal guideline across the bottom and a vertical line splitting the top sections for the large foreheads. Add circular muzzle shapes.

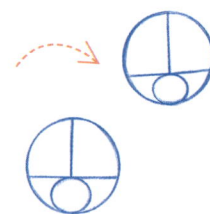

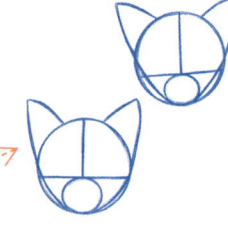

2 On each head, add two ears and trace another line from the bottom of the ears to the chin to make the shape more triangular.

124

3 Erase the previous guidelines for the cheeks. Start tracing the top kitten's body with a long guideline to the left and a shorter one under its head. Add a round shape on the left side of the lower kitten's head.

4 Trace the top kitten's right legs on each side, starting from the body lines.

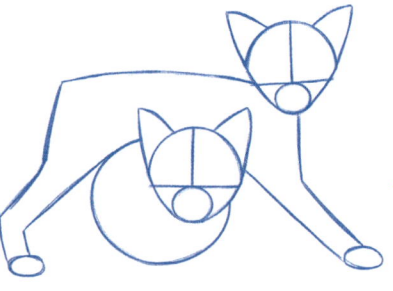

5 We only see three of the lower kitten's paws. Draw two at the front and a hind paw at the rear. Add the top kitten's tail shape and left legs (some parts are hidden).

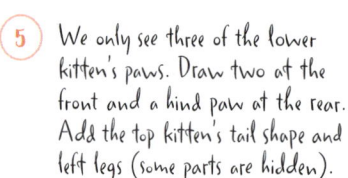

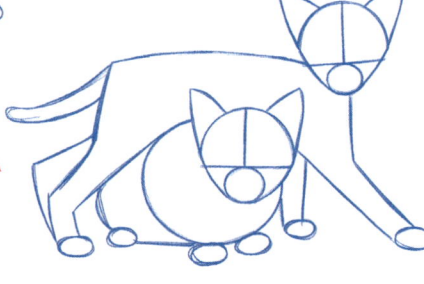

6 Using the guidelines, start drawing the eyes and nose of each kitten.

7 Draw the heads and ears, using quick, short strokes on the inside of the ears to create fur.

8 Trace over the front leg guidelines, using short strokes and adding oval paws with curved toe lines.

9 Finish drawing the bodies, adding quick, short strokes to resemble fur. Erase your guidelines.

10 Add a sandy base tone. The mask, ears, legs and tail, are darker than the body and merge gently with the base colour. Colour the eyes light blue or green, leaving a tiny highlight circle uncoloured.

Ocicat

The Ocicat's coat is short, sleek and spotty. The spots are scattered in a distinctive pattern on the sides of the body, extending down the legs.

1 Draw a circle guide for the head.

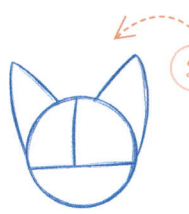

2 Add a horizontal guideline across the centre and a vertical line splitting the top section. Add two triangular ears.

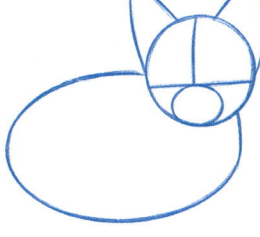

3 Add a circular shape as a muzzle guide. Trace an oval body shape, around three to four times the size of the head.

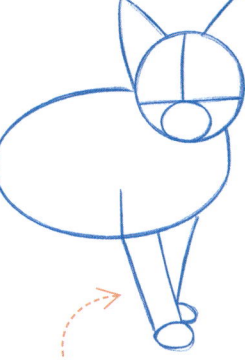

4 Add the front legs under the oval shape – one positioned in front of the other. Add oval paw shapes.

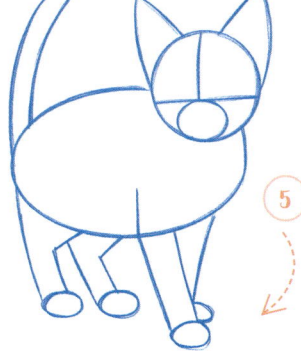

5 Add the hind legs and paws, and the tail.

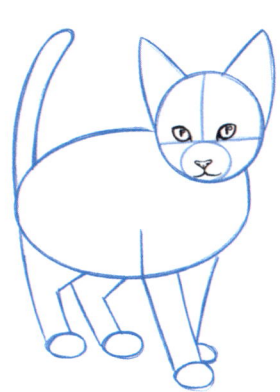

6 Sketch the oval eyes, using the guidelines for placement and adding two oval pupils. Draw the triangular nose and mouth.

7 Draw the ears and the front legs, using quick, short strokes on the inside of the ears to create fur. Add curved lines for the toes.

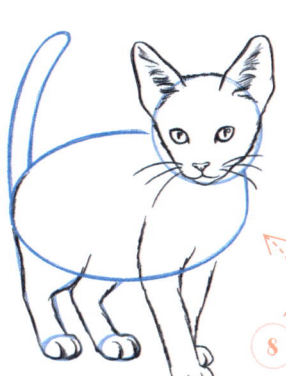

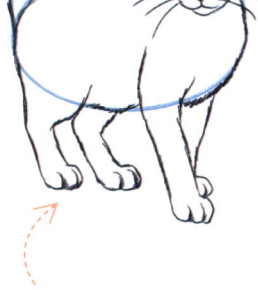

8 Use short strokes along the inside of the circle guide to create the wedge-shaped head. Follow the guidelines to draw the hind legs.

9 Use short strokes around the guidelines for the rest of the body and tail. Erase your guidelines.

10 Use a sandy base tone, leaving the chest and around the eyes white. Add the distinctive pattern with a dark ginger shade. Colour the eyes light green.

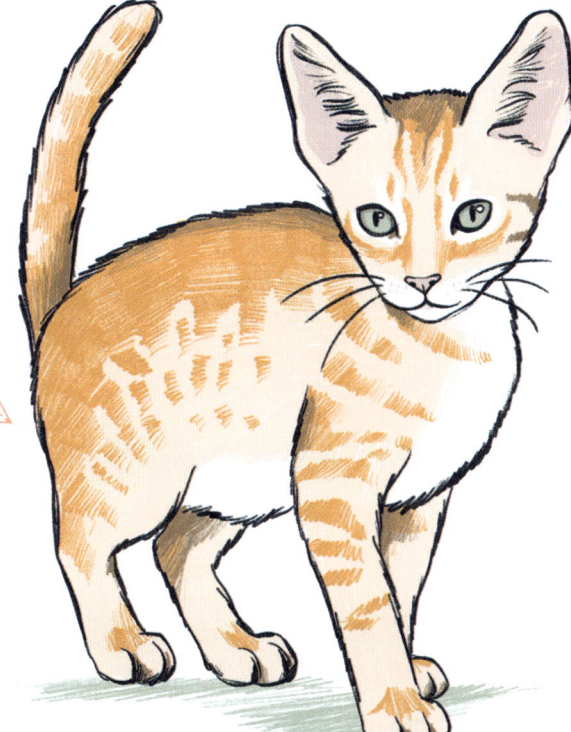

About the artist

Justine Lecouffe is an illustrator, designer and storyboard artist based in London, UK. Her work focuses on digital illustration, graphic design and some dabbling in motion media. Themes of femininity, beauty and nature often dominate her work, making it the perfect fit for clients in the fashion, jewellery and cosmetic sectors. She specializes in design and illustration, but has a long and ambitious wish list of styles and genres to master. When she's not drawing, you can find her cooking comfort food, cycling around London, snapping film photos or simply scrolling dog and cat memes.

If you'd like to find out more information or see further examples of her work, find Justine on Instagram @justine_lcf.

Acknowledgements

Many thanks to all the readers of *10-Step Drawing: People* and *10-Step Drawing: Everyday Things*, who gave me such positive feedback. This was wonderful encouragement and pushed me to draw for this third publication. And I'm again immensely grateful to the team at The Bright Press for another fantastic opportunity and their brilliant support throughout the project.